W9-AZD-104

VISIONS

Artists Living with Epilepsy

VISI
Artists Living

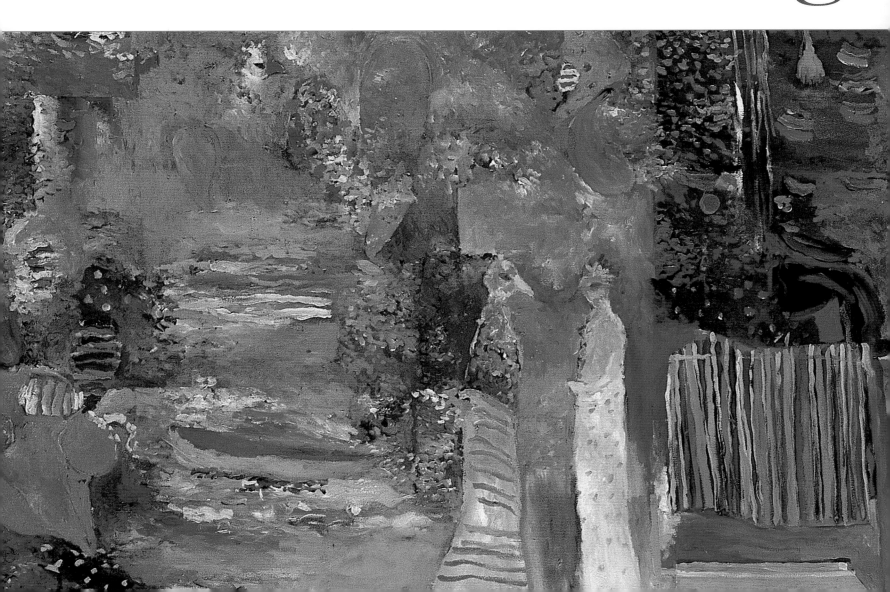

ONS
with Epilepsy

Edited by

Steven C. Schachter

Department of Neurology
Beth Israel Deaconess Medical Center
and
Harvard Medical School
Boston, Massachusetts

ACADEMIC PRESS

Amsterdam Boston Heidelberg London New York Oxford
Paris San Diego San Francisco Singapore Sydney Tokyo

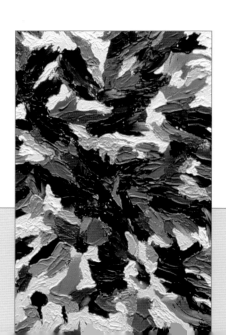

Interior design: G.B.D. Smith
Jacket design: G.B.D. Smith
Jacket artwork: Vincent Buchinsky
Endpaper artwork: James Talin

This book is printed on acid-free paper.

Copyright © 2003, Elsevier (USA).

All Rights Reserved.
No part of this publication may be reproduced or transmitted in any form or by any
means, electronic or mechanical, including photocopy, recording, or any information
storage and retrieval system, without permission in writing from the publisher.

Permissions may be sought directly from Elsevier's Science & Technology Rights
Department in Oxford, UK: phone: (+44) 1865 843830, fax: (+44) 1865 853333,
e-mail: permissions@elsevier.com.uk. You may also complete your request on-line
via the Elsevier homepage (http://elsevier.com), by selecting "Customer
Support" and then "Obtaining Permissions".

Academic Press
An imprint of Elsevier
525 B Street, Suite 1900, San Diego, California 92101-4495, USA
http://www.academicpress.com

Academic Press
84 Theobald's Road, London WC1X 8RR, UK
http://www.academicpress.com

Library of Congress Catalog Card Number: 2003109376

International Standard Book Number: 0-12-621358-5

PRINTED IN CHINA
03 04 05 06 07 9 8 7 6 5 4 3 2 1

To Susan, Michael, and David

CONTENTS

FOREWORD

Visions: Artists Living with Epilepsy is a unique work—a labor of love on the part of its editor, Dr. Steven Schachter, and a unique collection of artistic works produced by people with epilepsy. Within its pages you will see works of art that symbolize the creative ability and artistic visions of a dynamic and gifted group of people. Each page is a reminder that ability, not disability, is what is important in our lives. It isn't what these artists can't do, but what they can do—and do magnificently—that moves their lives forward and fulfills their spirits.

In so many ways, the images in this book are a tribute to the resilience of the human spirit and the power of personal creativity. Many years ago, Suzanne K. Langer, a student of the philosopher Alfred North Whitehead, defined art as "the objectification of feeling." It is often hard to describe art—one fumbles for the right words. But it isn't hard at all to *feel* art, to look at images and sense the power, the love, the anger, and even the despair that inspired them. Many of the paintings and other works in Visions are a passionate reflection of those emotions, the feelings that are part of living with epilepsy.

Living with any disability is a daily challenge. The challenge of living well with epilepsy is still far too often compounded by the lingering prejudices of the past. The spiritual power communicated through the pages of Visions is in itself a timely message for society: that people with epilepsy are a vibrant part of our world, and there should be no barriers to achievement or creativity.

The Epilepsy Foundation welcomes the publication of *Visions: Artists Living with Epilepsy* and congratulates Dr. Schachter on his personal vision of what could be accomplished in collecting these works and sharing them with others. The Foundation wishes to thank Bertek Pharmaceuticals for their support of this publication. We are also grateful that all proceeds from the sales of the book will be used to benefit the work of the Epilepsy Foundation, and to help bring about our shared vision of no seizures, no side effects, and a better world for people with epilepsy.

—Eric Hargis
President & CEO
Epilepsy Foundation
Landover, MD

PREFACE

pilepsy is a neurological condition that affects several million Americans. The main symptoms of epilepsy are recurrent seizures. A seizure is a brief and unexpected electrical malfunction of brain cells that causes an involuntary change in behavior or consciousness.

The goal of medical therapy is to prevent seizures. Fortunately, this is possible for the majority of people with epilepsy. Unfortunately, most people face discrimination and misunderstanding, whether or not their seizures have been successfully treated. This is because of the stigma about epilepsy, which dates back thousands of years.

Stigma results from lack of understanding and a tendency to focus on the disabling aspects of epilepsy. Education is an effective way to enhance understanding. But what is also needed is an emphasis on the *abilities* and individuality of people with epilepsy.

Over the years, I have been privileged to collect the beautiful and insightful works of artists whose lives were touched by epilepsy. Their courage and artistic expressions helped me understand and appreciate their abilities and individuality. I felt their visions and words should reach others, and so I assembled much of this artwork along with personal statements from the artists. The result was this book.

Seeing is believing—if you are prepared to believe what you see. I hope that as you experience the art and accompanying statements you too will come to believe that people with epilepsy are capable of wonderful accomplishments.

There are many people who played an important role in creating this book. I thank the artists for their courage and commitment to this project. I am grateful to the many health care professionals who put artists with epilepsy in touch with me. My assistant, Cecile Davis, deserves tremendous credit for her dedication to this book and the artists.

Epilepsy is often called a hidden disability because most people appear healthy between seizures. The purpose of this book is to suggest that many people with epilepsy have hidden abilities. May each of us, together with the Epilepsy Foundation, work to discover these abilities.

—Steven C. Schachter
June 2003

VISIONS

Artists Living with Epilepsy

PERSONAL STATEMENTS & ARTWORK

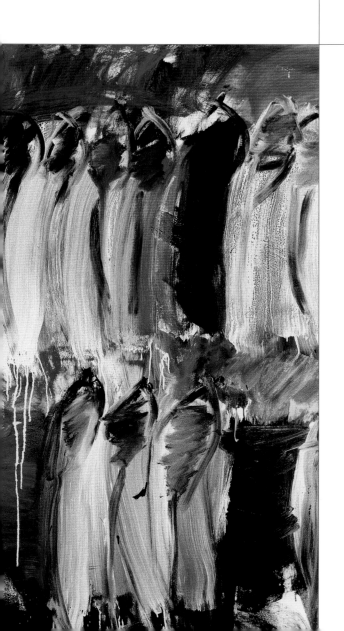

PATRICIA BERNARD

I am an artist and have been one for about as long as memory serves me. My epilepsy and seizures were diagnosed early, but were not treated till recently. Since I have been on treatment, I have become more and more aware of the challenges that epilepsy presents to my life and, of course, to my special work.

Another special challenge was that my family was very poor and not at all educated. There were no books, magazines, nor newspapers in my home, and learning past the three Rs not valued nor encouraged. I was the first in my family to finish high school, and have two associate degrees, one in art and another in computer science. For ten years I worked in special education, where my art was especially valuable.

As early as junior high, my art was often chosen for school exhibits, and, while the medium has changed from time to time, my skills have increased, my style has evolved, and I am hopefully wiser and certainly older. Still, artist is the way I define myself.

The Central California coast and forest provide me with endless scenes for my artistic expressions, and only rarely do other locations compete.

From early times it was clear to me that my paintings were full of color, form, and movement that was not photographic. It was not till I studied artists such as van Gogh, Michelangelo, and Edward Lear that I began to understand that they also painted an art that was different from the norm, and that they were considered successes in their field, either at the time they lived, or soon after.

I have found the courage to produce art that had color and movement that others may not understand. It is interesting to watch people look at my paintings. They vary the distance from their eye to the painting, obviously enjoying their experience as they find my perspective.

Play
2001–2002
Acrylic
20 x 32 inches

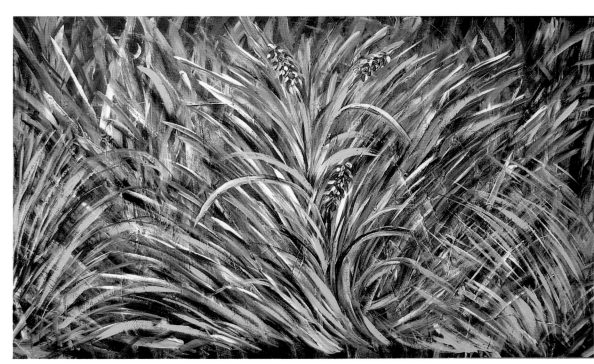

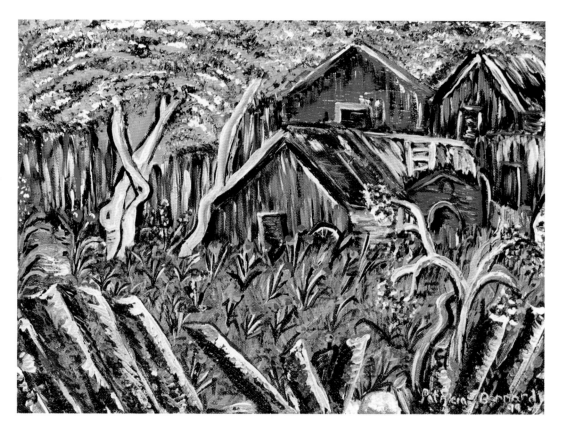

Springtime
2000
Acrylic
16 x 20 inches

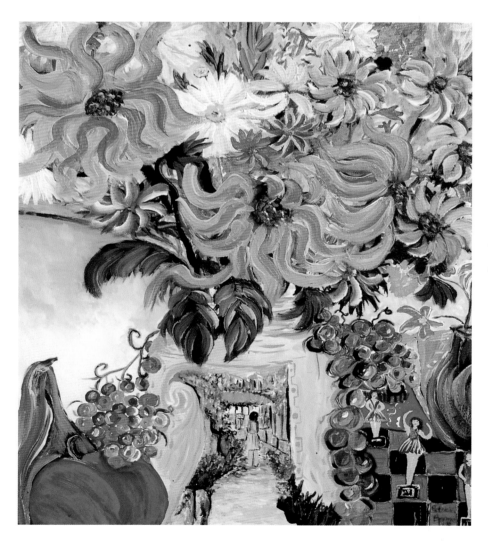

Alice in Wonderland
2002
Acrylic
18 x 24 inches

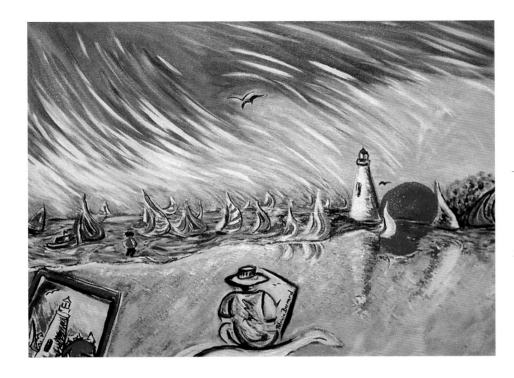

Artist Study
2002
Acrylic
18 x 24 inches

Bonny Doon
2001
Acrylic
18 x 24 inches

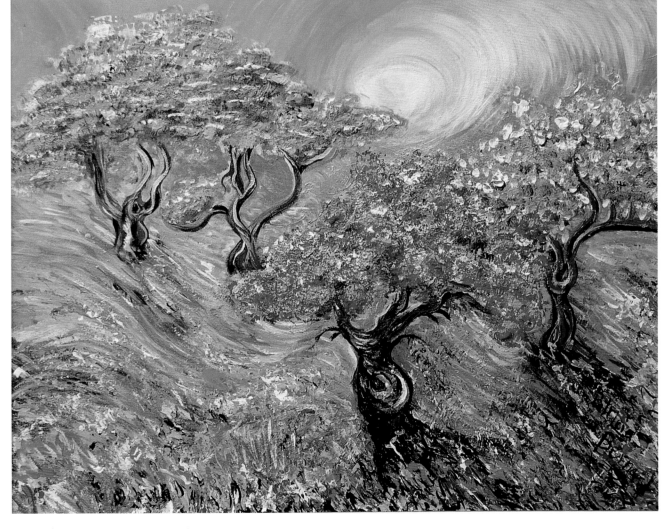

City of Barns
2000
Acrylic
18 x 24 inches

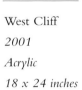

West Cliff
2001
Acrylic
18 x 24 inches

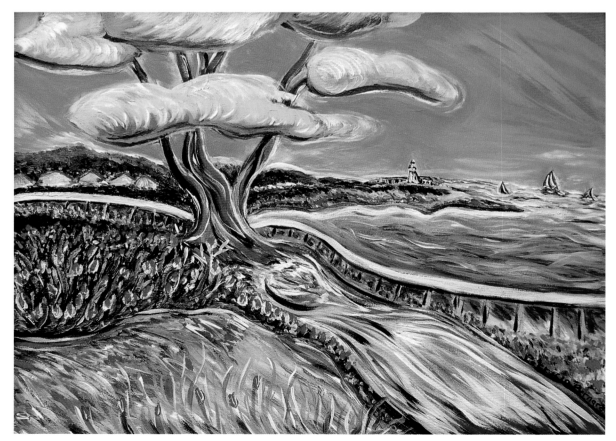

ELENA BLAISDELL

As I write this, I am home in St. Paul, Minnesota. It is 1:10 AM. It is typical for me to be awake at this hour. The medicine I take to keep me free of seizures often gives me insomnia. I was born on May 3, 1951. There was no indication that I had epilepsy until I was 5 years old, when I had pneumonia and went into convulsions because of a high fever. My epilepsy was originally attributed to that fever, but according to my current neurologist, it is actually due to scar tissue on my left temporal lobe because of a stroke I had at birth. He said the stroke caused so much scarring that the magnetic resonance imaging (MRI) scan of my brain looked as if I had been hit in the head with a baseball bat. Only I have never been hit in the head by anything.

As a child, I saw my neurologist four times a year for brain wave tests. He kept telling my parents, "She will grow out of it."

When I was 18, the doctor took me off the seizure medication. I did not have a seizure for three years. But my complex partial seizures returned when I was 21. I restarted seizure medication.

I went to England soon after that to visit my brother, who was stationed in the Air Force. It was there that I met his roommate, Mark. We wrote to each other everyday for two months and then he asked me to marry him. He was from St. Paul, Minnesota. Now you know how I got here.

After I was married, my seizures continued. Soon, though, I once again went off the seizure medication because I wanted to get pregnant. Mark and I now have a 29-year-old daughter. Her name is Lisa.

Over the years, I have been on various combinations of seizure medications. Mark would remember the details of my medication cocktails. He is a critical care registered nurse and has a better memory than me, because my memory has been severely affected by the seizures.

My seizures really got bad when I reached my mid-thirties and had gone back to college. One day I was coming home from school when I had a seizure one block from my home and fell face down in the snow in front of a gas station. The police had to drive me home. When they asked me my name, I told them my maiden name. I had been married 18 years at that time.

Things got worse. In 1989, over Labor Day weekend, I had 17 seizures. It was then that we began looking for a neurosurgeon and new neurologist. I not only had a left temporal lobectomy, I had an anoxic stroke three hours later while I was in ICU doing a New York Times crossword puzzle. I dropped my pen and could not move my entire right side. The only thing that kept me going was my stubborn New York nature. I called the nurse with my left hand, looked up to God and said, "Sorry You screwed up! You only took half of me! I'm taking it back!" I had been painting since I was six years old. Nothing was going to stop me from painting again.

I was using my right hand within 3 weeks and walking without a cane within 3 months. Then Mark and I went on a Caribbean cruise and I climbed Dunns River Falls just to prove I could do it!

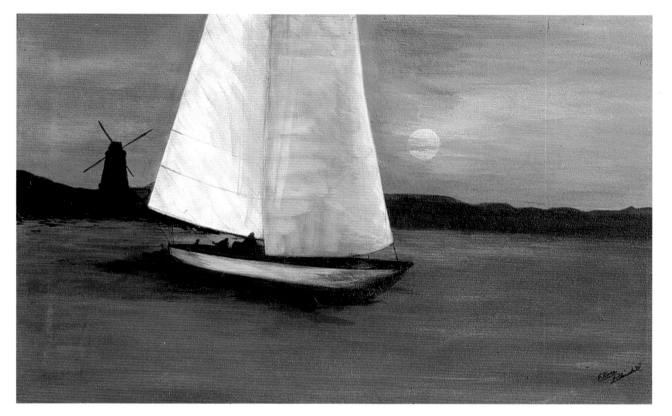

Norfolk Broads

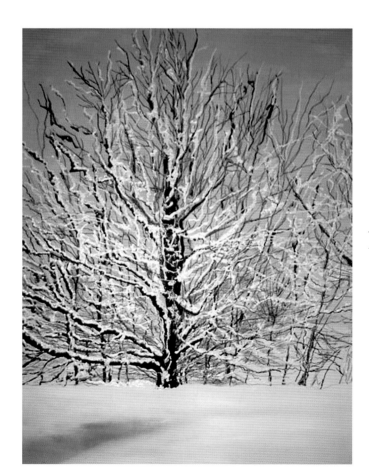

Winter's Back

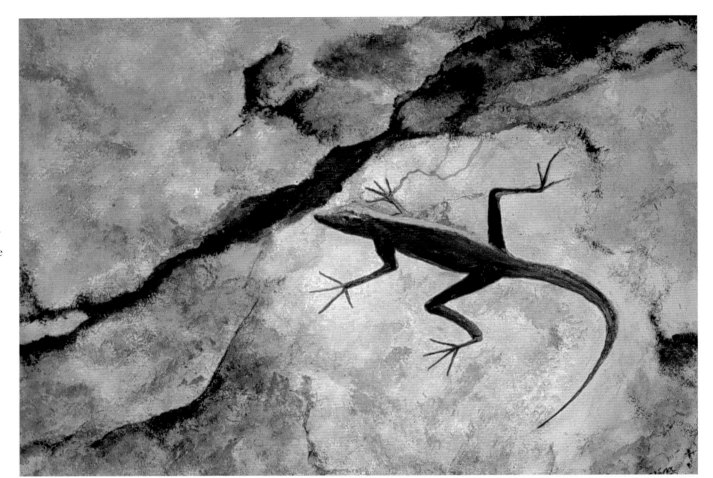

Camouflage

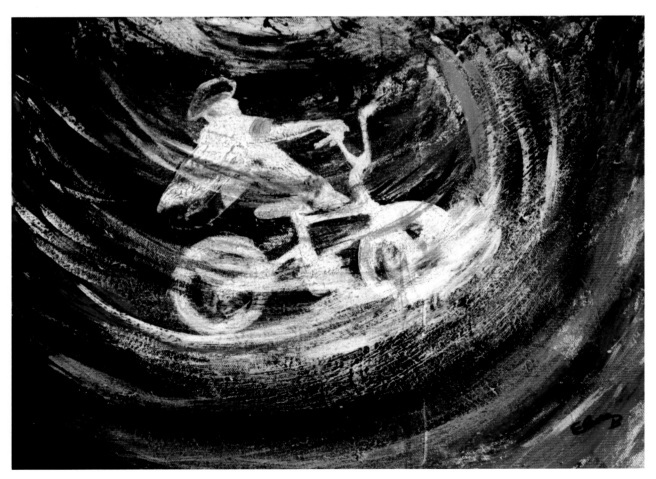

Free Wheelin'

VINCENT BUCHINSKY

I was diagnosed with complex partial seizures and temporal lobe epilepsy seven years ago. My artwork has been described as "haunting and spiritual." I do not illustrate the effects of epilepsy, but epilepsy influences what I express. My work is not merely limited to this seizure activity, but emotions in general. My art is influenced by my inner emotional life, which we all share.

Some of my works are expressions of the effect of seizure activity, which causes me to have a heightened sense of detail. During times of derealization, this sense is magnified and perception of my surroundings become almost too intense. For this reason, I am attracted to texture and the juxtaposition of shapes. This is a dominating theme in most of my work.

I am also aware at times of feeling a void due to seizure activity. This manifests itself in much of my work as a circular space or an overall emptiness. I work in a variety of mediums, including oils and acrylics, which I balance with my computer art.

Art is just the act of sharing.

A Very Fine Balance
1998
Digital print
12 x 12 inches

Insomnia
1998
Digital print
12 x 17 inches

02b
2002
Digital print
16 x 20 inches

Between
1997
Digital print
16 x 12 inches

Saturday Morning
1997
Digital print
16 x 16 inches

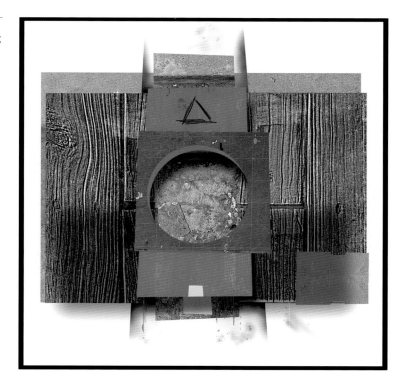

Red Monument
2001
Digital print
15 x 15 inches

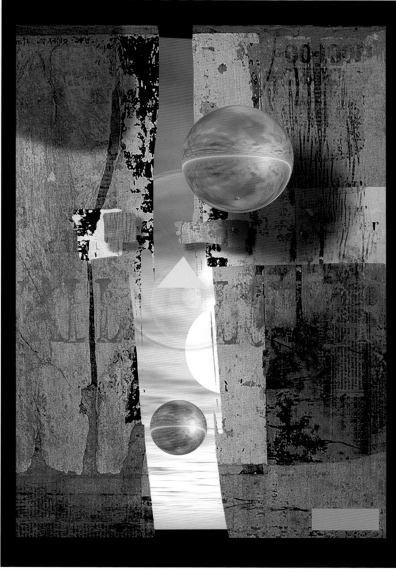

Escape
2001
Digital print
16 x 11 inches

Houses on a Hill, Version 1
1997
Digital print
11 x 9 inches

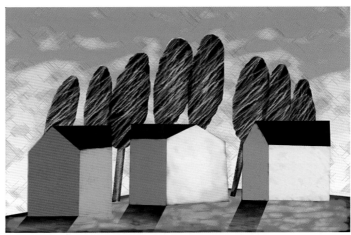

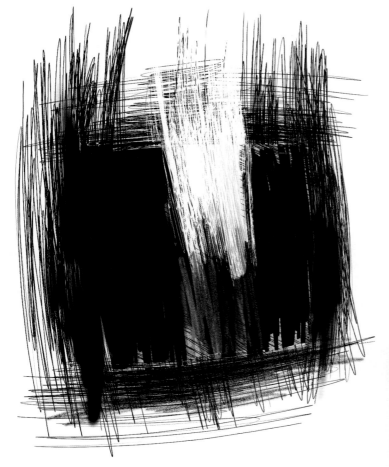

Rainbow Box
2003
Digital print
16 x 16 inches

Untitled
2003
Digital print
14 x 11 inches

JIM CHAMBLISS

During the transitions of life, circumstances change and people evolve. I have in many ways found my visual voice and discovered my "Artistic Side" since suffering a brain injury and traumatic epilepsy. On August 19, 1998 I was blindsided by an SUV while standing in a parking lot. I suffered knee, back, neck, and brain injuries. I walked away from the auto accident scene, but could not leave behind the unexpected consequences that have so substantially changed my life. I have since had seizures and cognitive problems. Seizures led to other accidents such as stiffening up and falling like a tree on my face, plus wrecking my car, which made my situation worse and more isolating.

My brain damage was primarily on the left and front parts of my brain. I view the left brain as the efficiency side responsible for processing words, numbers, lists and sequencing while the frontal lobe is the control center. The right brain is the artistic side because it is responsible for functions of creativity, intuition, and physical coordination. I communicate in visual images more now, because of my clumsiness and mental mistakes with words, numbers, and lists. It helps me to literally see what I am doing.

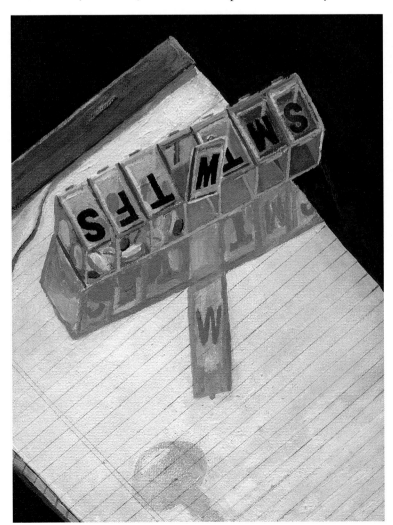

The human body and mind find ways to compensate and adjust for one's weaknesses. I am studying to become an artist and art teacher. I have chosen to use the functions of my brain that now work the best, rather than the continued struggle and frustration of trying to regain what is lost and now out of my reach. I had virtually no artistic training before my injuries. I am curious why

Shadows of the Past
2002
Acrylic
9 x 12 inches

I have such a rapid learning curve with art. The first painting I completed called "Shadows of the Past" won a class award and my sculpture "Broken Crank Organ" won an award for "Best Ceramic Sculpture" in the first art exhibit I entered.

"Shadows of the Past" is a visual narrative of some changes I have gone through since I was blindsided. I painted my weekly pill bottle as turned upside down, much like my life. The lid for Wednesday is open with the shadow of a "W" on the blank legal pad symbolizing the day that led to the eventual loss of my law practice and beginning of my struggles with epilepsy. Pills of the remarkably expensive seizure medication are pictured in the compartments for the following days. There is a shadow of the key to my car I wrecked after a seizure around 5½ months after I suffered the brain injury. I still miss what my life was like before I got blindsided. But, I am pleased to discover another career and medium of expression through art.

Photographed by Todd Barns

Broken Crank Organ
2002
Ceramic sculpture

PAMELA DAVIS

If it weren't for art in my life and my love for it, my life would have taken a much different path. I can't imagine it any other way. I had an early fascination for the visual arts—one particular recollection stands out. When I was about 9 or 10 years old the passion for art drew me to ride my bike to all the local galleries and examine every painting to learn more about the artists who painted at that time. Depth and shadow interested me. Since then I have enjoyed every aspect of the profession of art. Opening nights in galleries always bring back memories, especially when I see a young person (or artist) come in and admire the art.

Even though there have been obstacles, they haven't curtailed my progress to be the best artist I can be. Obstacles can be overcome or gone around. In 1989, I was diagnosed with epilepsy when complications started in the second trimester of my second pregnancy. My first symptoms where actually tracked back as far as 9th grade, but they were never noticed at that time. This was the main reason I struggled in high school.

I am realistic about the fact that epilepsy is a part of my life. Some days are not going to be kind, but I can take my meds and hope that the meds prevent any more seizures.

Rosey
Oil

We Stand Together
Acrylic

Boca Palm
Watercolor

Garden Pool
Watercolor

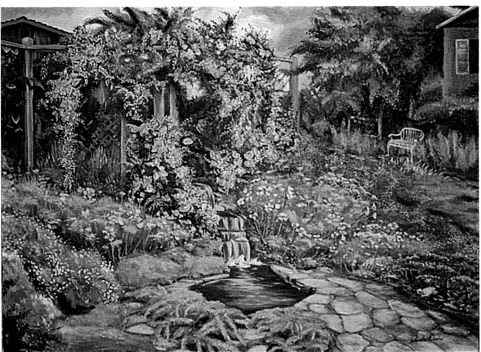

Lost in Flowers
Oil

Girl Play
Oil

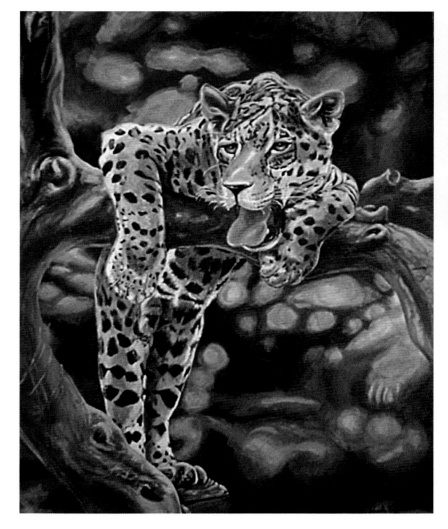

Jaguar
Acrylic

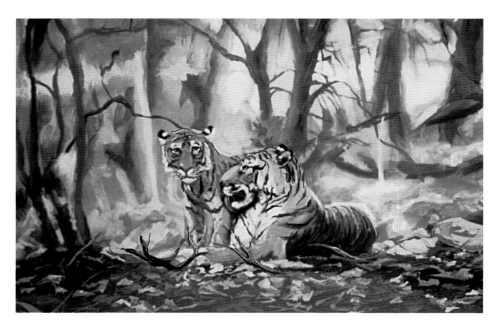

Lounging Tigers
Acrylic

ISABELLE DELMOTTE

I n the early 1990s I had the opportunity to express the loneliness of an epileptic condition through an art project ("Epileptograph: the Internal Journey") and with the help of numerous institutions and individuals in Australia but also overseas (amongst others Dr. Steven Schachter). This particular project will always be in progress as it has helped me to develop a physical awareness and an emotional knowledge of my own physical and emotional condition.

Most importantly, this artistic endeavor has allowed me to evolve in a more serene way that could not have been forecast 20 years ago, and that has been beneficial to anyone close to me.

I do think that my artwork has evolved in the same way as the physicality of my thoughts and emotions, and today life is as precious as it always could be but lighter and definitely shared in a more colorful way.

Transition
2003
Computer graphic
Size at will

Epileptograph
1992
Still excerpt from video

Seismic
2002
Computer generated
Metallic print or duratrans
Size at will

Flow
2002
Computer generated
Metallic print or duratrans
Size at will

Epileptograph
1992
Still excerpt from video

Tea with the Octopus
2002
Computer generated
Metallic print or duratrans
Size at will

Epileptograph
1992
Still excerpt from video

ELAINE M. ERNE

I have been doing art all my life. My parents were against coloring books so it was blank paper, crayons, markers, paints, and imagination. My artwork expands over several mediums. The sculptures made of kiln-fired glass and found objects represent feelings of loneliness that health and family problems may cause a person throughout his/her life. The environments, made of old discarded materials juxtaposed to the clean smooth surface of the glass figures, create a feeling of isolation. This is a feeling many people experience in times of distress.

The series of graphite drawings and prints depict the lives and traumas of stuffed animals. Using toys as an allegory for people allows me to explore the inner workings of a family without being immersed in the reality of difficult interactions. The dolls encapsulate the personality of a family member and become a vehicle for discovery. Though the situations represented are far from real, they capture the aura that surround a family who on the outside appear happy while actually experiencing deep sorrow and tension in their daily lives.

Photographed by Joe Miculiak

Photographed by Joe Miculiak

Mr. Clown's Fan Club
2002
Graphite drawing
41 x 27 inches

Rethinking a Wish
2000
Kiln-fired glass, steel
washer and wood
machine mold
8.5 x 8.5 x 5.5 inches

Photographed by Joe Micaliak

Point to the Past
2000
Kiln-fired glass and
steel steam vent
4.5 x 6 x 6 inches

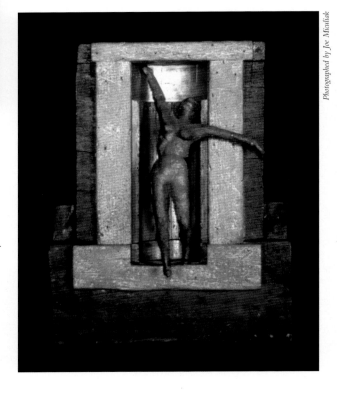

Photographed by Joe Micaliak

Freedom to Let Go
1998
Kiln-fired glass, wood machine
mold, steel washer, copper leaf,
and acrylic paint
12 x 9 x 9 inches

Leap of Faith
1991
Kiln-fired glass, wood
machine mold, and gold leaf
16 x 12 x 7 inches

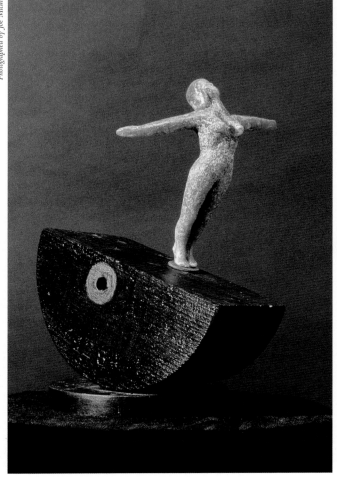

Photographed by Joe Micaliak

Snugglebunnie Hears, Sees and Speaks No Evil
2003
Woodcut
12 x 18 inches

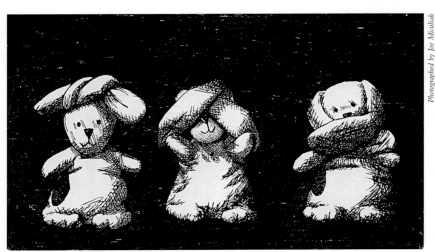

Photographed by Joe Micaliak

WOLFGANG FEHRING

I was born in 1958. I am married and have 2 children. I was educated in pedagogy and work as a caregiver in a residential facility for young people with epilepsy and additional handicaps. In my piece called "Interruptions," the cracks in the wall symbolize the seizures that constantly interrupt the normal day of the young people who I work with. Margarete Pfafflin says that the children in our hospital especially like this work because there are so many well-known things to "discover," like money, a coffee machine, medication, and a bed. The question "and what kind of things belong to your day" often starts an interesting conversation.

The painting called "Separate" is symbolic of the distance that our society often puts between people with epilepsy and itself.

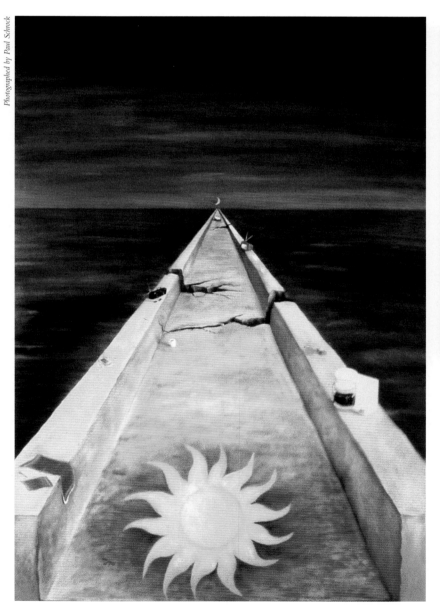

Photographed by Paul Schrock

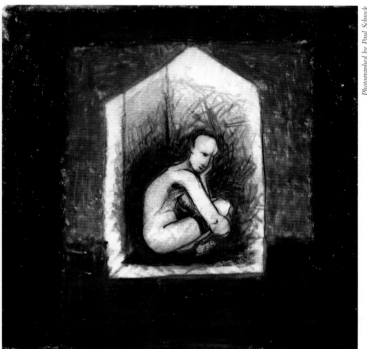

Photographed by Paul Schrock

Interruptions	Separate
1999	*1998*
Oil	*Oils, pastels, and pencil*
70 x 100 centimeters	*12 x 12 centimeters*

23

MIKE FELTEN

A rt is the highest category of hope. I have no direction, no aim. I just paint. The outside, the bubbling surrounding, is my sponge, my medium. There is no existing program, no style, no concern. I don't like technical problems, working themes, variations up to mastership. I escape from every determination. I don't know what I want. I am not rational; I am languorous and passive. I like the boundless, undetermined things and continual insecurity. Other characteristics work for success, for advertising, they are in either case obsolete like ideology, minds, terms and names for something.

After the disappearance of priests and philosophers, artists are the most important people in the world. That is the only thing that interests me. The jungle is the best example. Everything grows as it wants. It doesn't grow arranged or sensible; it just grows under determined conditions like space, food, and so on, which are existing casually, being neither good nor bad nor leading independently to an aim or purpose.

When we describe activity, write a bill, or take a photo of a tree, we create patterns. Without them we would not know anything about reality and would be animals.

My abstract paintings are fictitious patterns, because they exemplify a reality we neither can see nor describe, but draw a conclusion about its existence.

I live and work with epilepsy.

Tension and unloadings develop and are built up without an awareness of analysis. These fields are an important basis for my art. I do not define the "spikes" diagnosed by medics as a disease but as a part of my personality, expressed in the dissimilarity of my painting. I exist as an artist through diving into the depth of impressions, which deal automatically with the different fields of tension in my person and find their expression in my art.

My painting comes out of intuition. It doesn't ask if it is right or wrong but follows unconditionally a mission without knowing its motivations. I paint or create art for itself.

Landschaf aus dem Fenster
2002
Acryl, mixed papers
1.5 x 2.5 meters

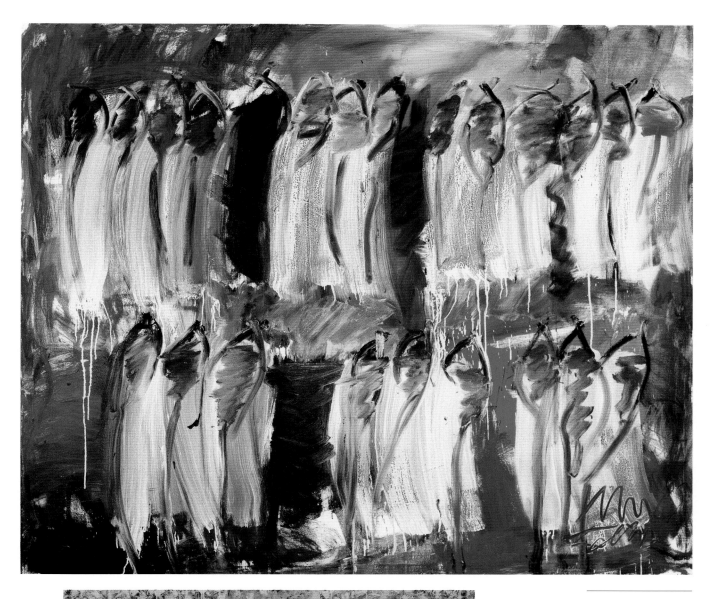

Sardinen
1999
Acryl, canvas
2.00 x 2.10 meters

Trilogie – Gelb
1999
Oil, canvas
2.20 x 2.10 meters

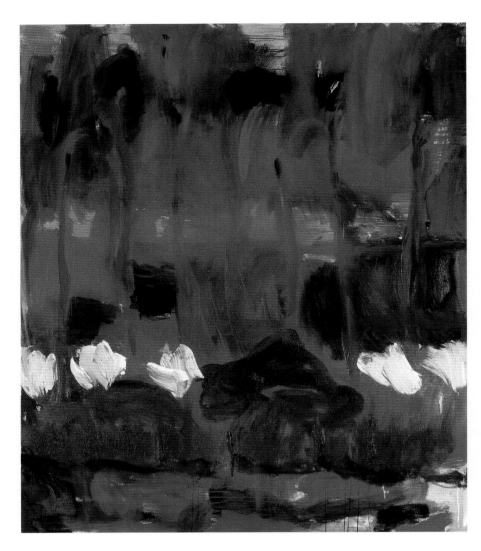

Untitled
1999
Acryl, oil, canvas
2.50 x 2.00 meters

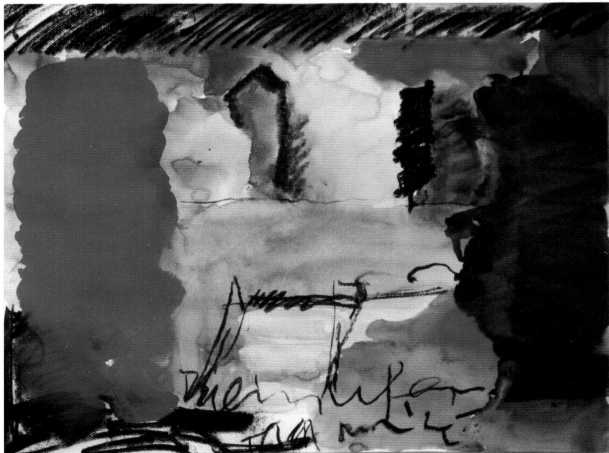

Rheinufer
2001
Aquarel, paper
0.40 x 0.50 meters

CRAIG GETZLAFF

I have had epilepsy my whole adult life. In this series of paintings I am trying to depict both physically and emotionally what it is like to experience a seizure or, more accurately, a lifetime of seizures. I have read many books about seizures and epilepsy written by doctors and other neurological experts. These books try to scientifically show what happens during a seizure. They say that during a seizure electrical impulses randomly scatter across the neurons in the brain, much like a thunderstorm within the brain; hence the series title, "Brainstorms."

A seizure is a very intense experience. All of your emotions and sensory perceptions are on serious overload. Everything seems to be coming at you and swirling around you all at once. On top of all this, and only at the very beginning, you realize that you are having a seizure. You don't know if it is going to be a mild seizure (which will still drain you for days) or a very serious seizure (which could place you in a coma or you could possibly be killed during an episode). Your anxiety and nervousness go skyrocketing through the roof during this event.

In these paintings, I am trying to communicate to the public and to myself what an immense experience a seizure really is. And hopefully, during my studies of my seizures I will be able to gain at least a small amount of control over them and find meaning to them. Most of what I have done in this series relates to the sporadic uncontrollability and the intensity of the experience. The thick heavy sporadic brush marks (pallet knife marks), the swelling motion in the paintings, and the intense colors and contracts in the pieces. Each layer in the painting is put on while concentrating very intensely and working very spontaneously, similar to Jackson Pollock's action or drip paintings. I am painting the edges of these pieces and using extremely thick paint in order to convey that the part of a seizure that can be remembered is on the border between the conscious and unconscious mind just as these pieces are on the border between painting and sculpture.

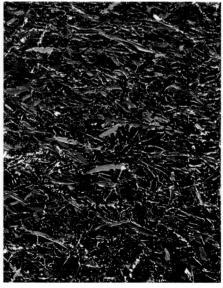

Brainstorm #19
2002
Acrylic
Dyptic 24 x 18 for each piece

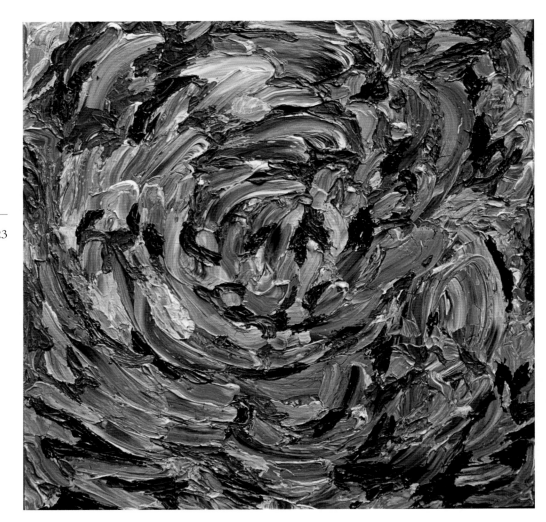

Brainstorm #23

2002

Oil and acrylic

48 x 48 inches

Brainstorm #20

2002

Acrylic

Dyptic 36 x 24 for each piece

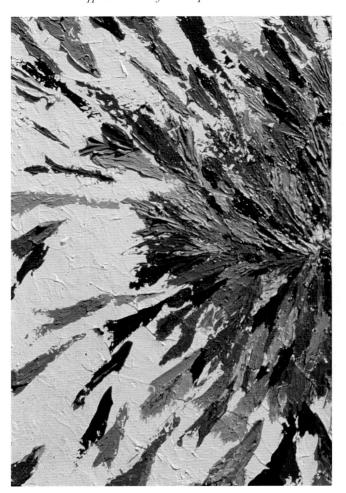

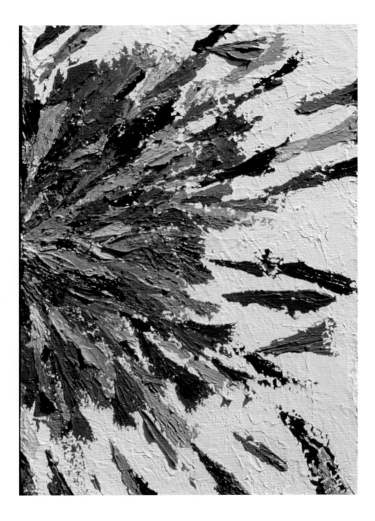

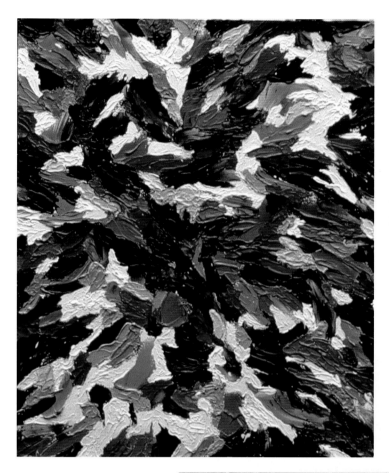

Brainstorm #7
2001
Acrylic
30 x 24 inches

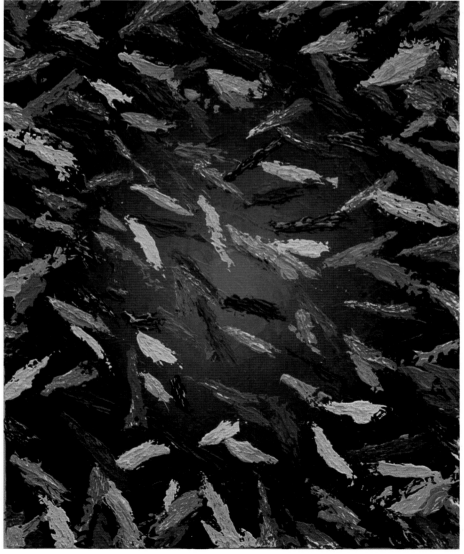

Brainstorm #9
2001
Acrylic
30 x 24 inches

Personal Statement

JENNIFER HALL

The origin of consciousness and its place in introspection's structuralism is also an important reason why I chose to work with images of, and data from, my own body. As with all self portraits, the peculiar aspects that make the art interesting are those qualities that make it unique. In this spirit, I celebrate other states of consciousness that make up the numerous natures of mentality and the paradoxical state of my biological, electronic, and chemical self.

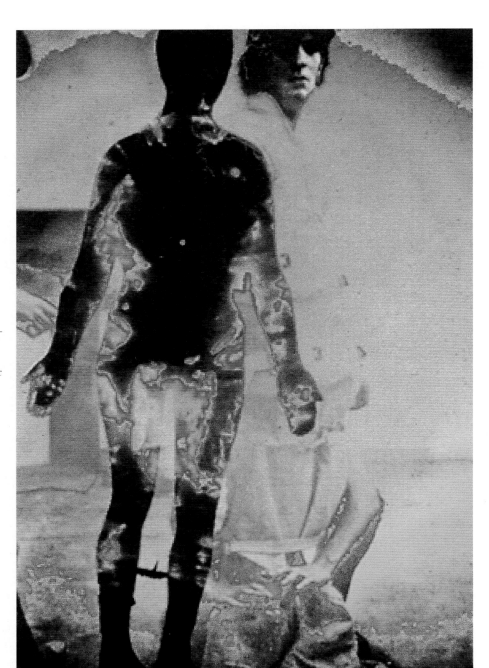

Transcending
Computer graphic

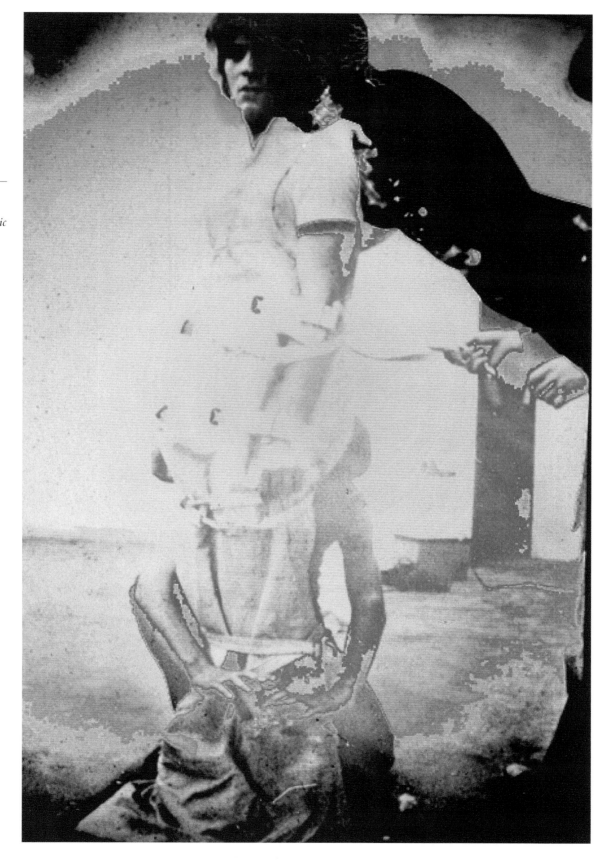

Transcending
Computer graphic

ROXANNE HILSMAN

I don't feel like my seizure disorder has ever affected my artwork, but I do believe that my art allows me to focus and relax, and gives me a wonderful sense of well-being.

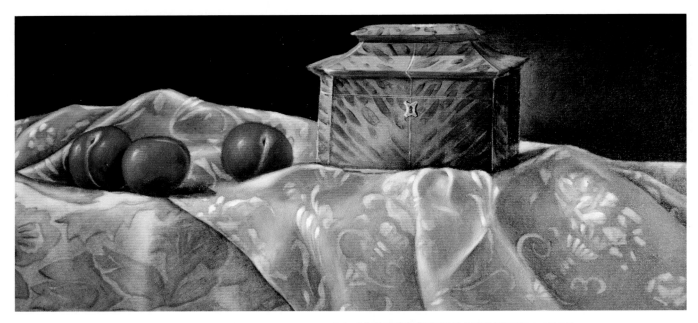

Plums & Tortoise Shell Box
Oil on canvas
12 x 24 inches

Stacked Imari
Dishes
Oil on canvas
24 x 18 inches

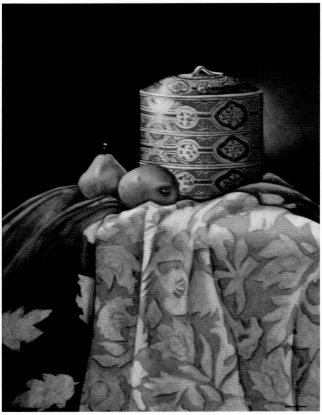

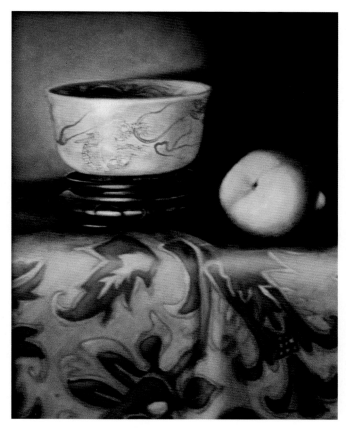

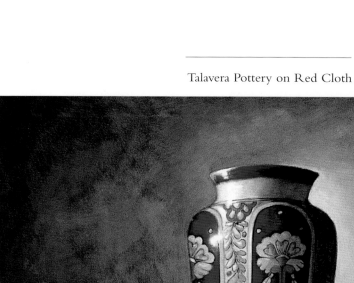

Imari Bowl and Pear
Oil on canvas
11 x 14 inchs

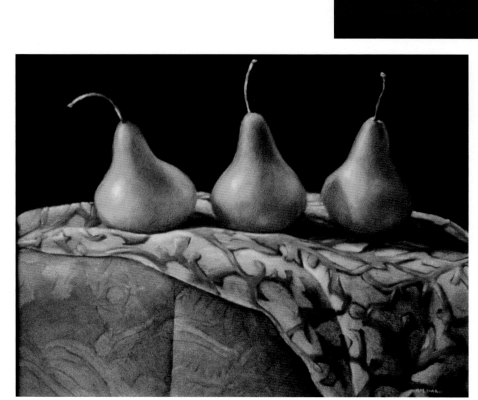

Three Pears on Fabric
Oil on canvas

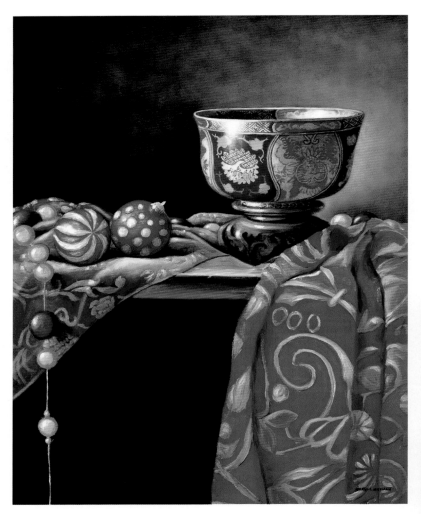

Imari and Orbs

Pears on Table
Oil on canvas
11 x 16 inches

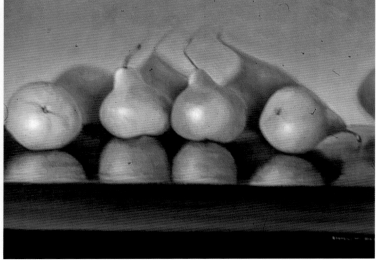

Three Pears
1998
Oil on canvas
12 x 16 inches

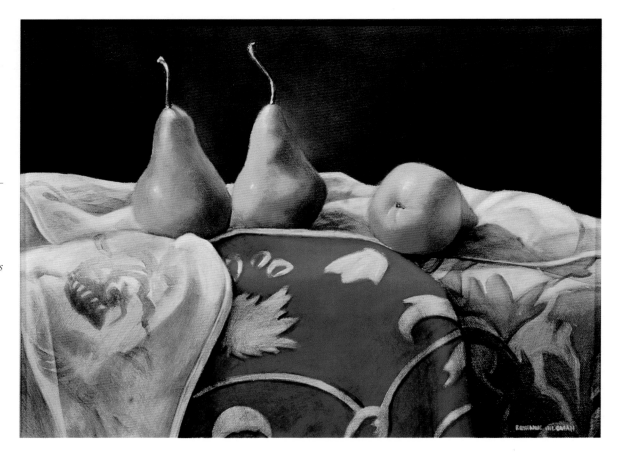

TIM HULTS

Growing up with epilepsy put a lot of limitations on me. As a teenager I struggled with complex partial seizures on a daily basis. Photography has helped me cope with my epilepsy by focusing on the beauty in the world that I see through the lens of my camera. It is also a wonderful way to reduce stress, which often was the trigger for my seizures. I would like to thank my Uncle Joe for taking me under his wing and teaching me about photography. I would like to thank Dr. Stanley Johnsen of Barrow Neurological Institute and Dr. Joseph Drazkowski of The Mayo Hospital in Phoenix for their support and friendship in keeping my epilepsy under control.

Eagle–Adobe Mountain Wildlife Center
1999
Photograph

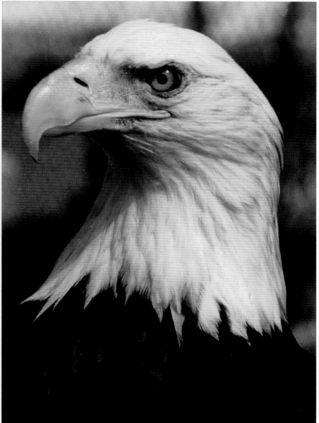

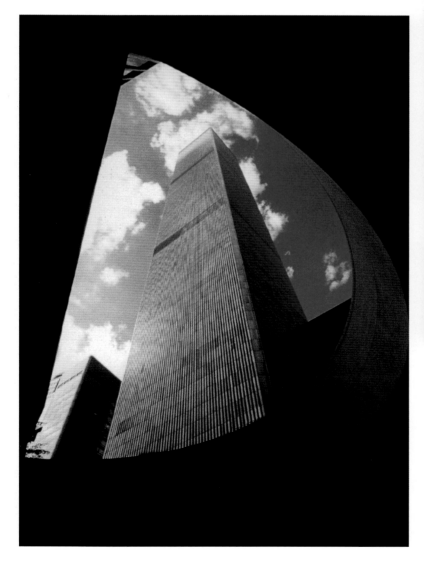

World Trade Center – July 2000
2000
Photograph

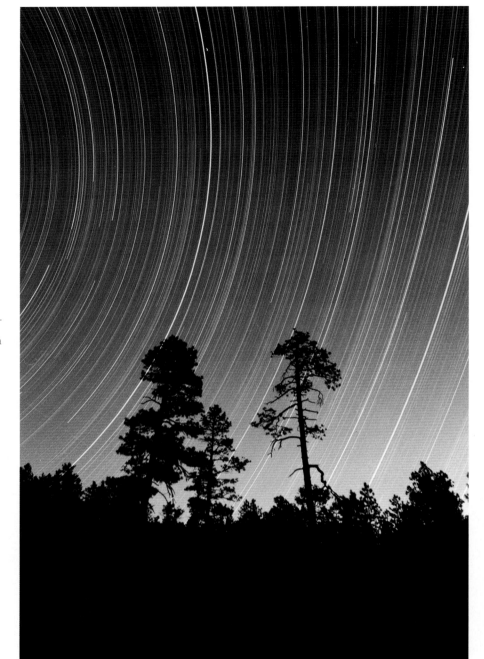

Star Trails – Mongollon Rim
1994
Photograph

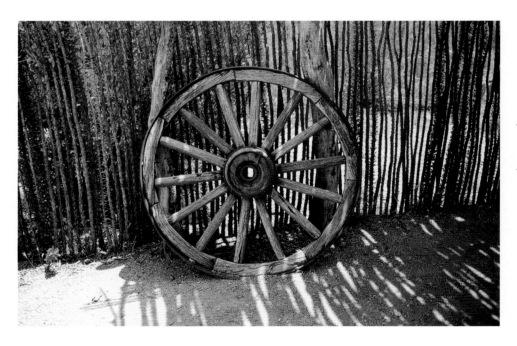

Wagon Wheel on Ocotillo Fence
Desert Botanical Garden, Phoenix, Arizona
1996
Photograph

ANNA-KATRINA'S DISCOVERY

(Written by Leonard and Marilyn Lehrer)

Our daughter, Anna-Katrina, was 5½ years old when our family spent several months in Italy and Spain. She loved the sound of the language, the smell of the food, and the visual beauty of the art and architecture. After we settled into our Madrid apartment, we took a leisurely walk to San Antonio de la Florida, a small government-owned former church which was renowned for the vibrant, painted frescoes in the dome and on several walls by the Spanish master, Francisco Goya. After concentrated examination and discussion of each image, we began moving towards the exit. Anna-Katrina's body stiffened in her wheelchair while making loud protests to our leaving. We asked if she wanted to have more time with Goya's paintings. Her body instantly relaxed and we began another very slow circle around the small church. Anna's absorption was absolute. She devoured these works with her eyes, carefully scrutinizing the paintings up and down, side to side, with an intense, pleased, and at times puzzled look on her face. She slowly let herself relax and sink more comfortably into her chair…art and Anna-Katrina had connected.

This experience represented a certain kind of beginning, a search for expressions and identity for a young lady who had not been presented with the standard means for development and discovery. Through the Goya experience, it was very clear that Anna would find her particular way of letting the world know she was here. Within the next year she was painting regularly with me in our studio. I devised a system of attaching brushes to her hand with Velcro strips, placing her wheelchair a precise distance from the easel, and selecting colors from paint swatches on 3 x 5 cards via a smile or the twitch of an eyebrow (or conversely, a nonexpression until her 'choice' was displayed). Once a color was agreed upon, the brush was loaded with the acrylic paint, Anna's elbow was rested on the wheelchair arm, and slowly she moved her lower arm forward until the Velcro-extended brush tip engaged the surface of the paper. Then magic happened! The resistance of the brush on the paper spurred her on as did the selection of the next color (she finished one color at a time and communicated a blank or bored expression if she wanted a change of color).

Slowly, the complexity of colors and brushstrokes took on the certainty of statements, expressions of pleasure, glee, richness, freedom, and endless possibilities—playful, exploratory, calligraphic. She often looked in wonderment at the marks and early on realized she was seeing an extension of herself…she had created something real, tangible, and exuberant, something she had brought to life. She knew this and wanted everyone to know it. We were happily surprised that Anna even had the stamina to make these paintings. The sheer motivation to produce these works, to see a reflection of herself through her art, challenged her physical capacity to its limits. She began spending time with me in the studio painting and listening to stories about the world of art and regularly offering her critical opinions through her carefully orchestrated eyebrow movements, smiles, sounds, diverted glances, or intense stares.

Nonverbal, quadriplegic, battling a variety of medical issues including epilepsy, which was uncontrollable until she was around 15 years old with the introduction of new medications, and often in great distress and severe pain, Anna-Katrina's focus was on what she could do, not what she was unable to do. Her focus throughout her life was on the wonderment of her world (with all its warmth, humor, and love). She learned early from Francisco Goya that brushstrokes and color could convey a multitude of emotions and thoughts and could also commemorate life in very direct and joyous ways. We believe these were choices she made early on, calculated and inspirational choices that took her through her brief life's sojourn with a celebratory zeal that was a definition of Anna-Katrina herself.

Untitled (Yellow
Background)
1996
Computer drawing
7 x 9 inches

Untitled (Red
Background)
1996
Computer drawing
7 x 9 inches

LEONARD LEHRER

My drawings and prints of Anna's hands are efforts to enter into, and better understand, her Herculean efforts to communicate. Each image is an attempt to grasp the spirit of her intensity. Her hands, to a great extent, became choreographed images of grace, delicacy, frustration, power, complexity, surprise—and a relentless commitment to contacting and embracing all those in her world. She was determined to let her presence be known as well as understood. My art permits me to better understand her efforts and remain in very close contact with her. They are also my way of sharing her with the larger community. Drawing her hands is, at times, very much like touching her hands, her spirit.

Maesta
1996
Mixed media on panel
48 x 36 inches

Untitled (Arm and Fist)
2000
Lithograph
40 x 30 inches

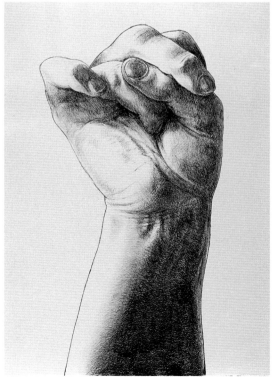

Maesta (Detail)
1996
Mixed media on panel

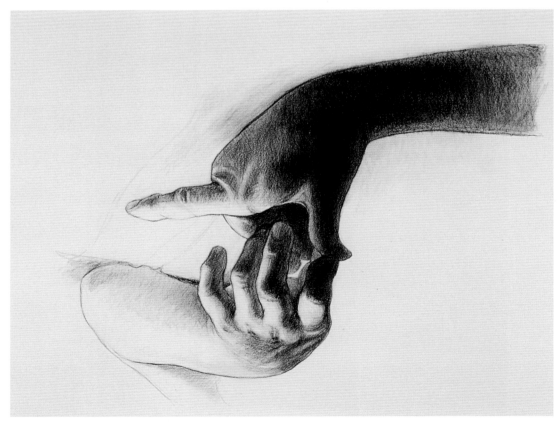

Dialogue
1999
Charcoal on paper
22 x 30 inches

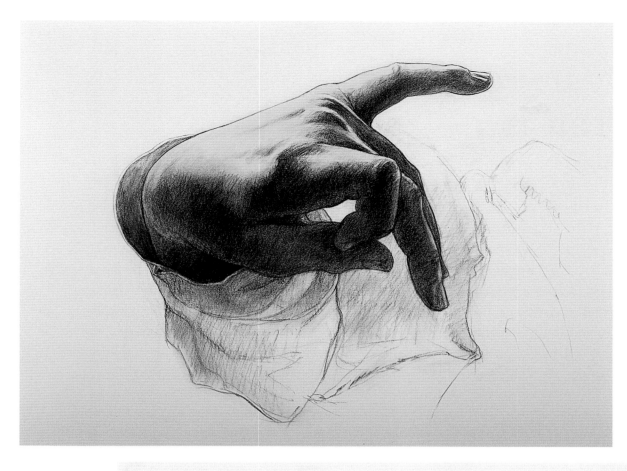

Untitled (Hand)
2000
Charcoal on paper
22 x 30 inches

Untitled (Feet)
1999
Charcoal on paper
22 x 30

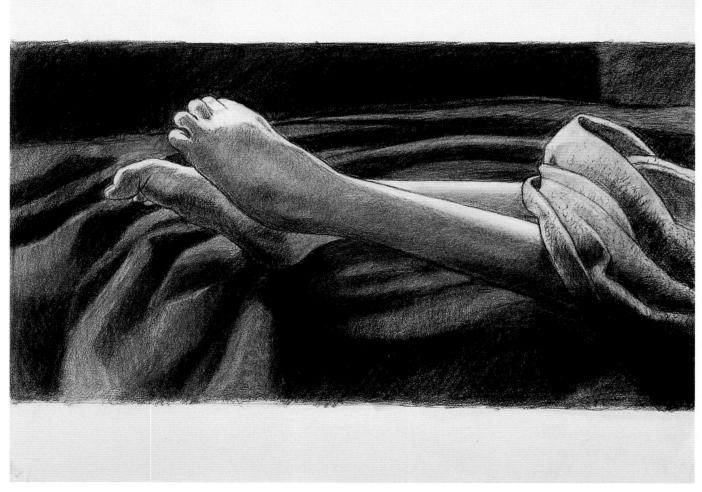

GERIE LEIGH

Epilepsy has me in its grip right now. I change brains with each new drug until I succumb to side effects or the drug no longer works. Compared with before epilepsy, my art work changes with each drug change. Currently, there is none. Five years ago, at age 53, I had a car accident in which three cars hit me from behind. My car was barely scratched, but the violent motion of multiple impacts shook my head and jerked my neck backwards, leaving me shaken and disoriented. My neck swelled up and 10 days later the pupil on one eye dilated totally. I was taken to the emergency room and tested for an aneurysm or other possible blood flow problems. I was admitted for observation, but the diagnosis of seizure did not come until a month later.

At the time of the accident, I was a senior high school art teacher in the top-ranked school in the nation. I taught advanced placement and IB college level classes and I loved my work. I was a Type A over-achiever and was involved in school, community, and environmental causes. I had a husband, two children, and grandchildren.

The episodes were a nuisance and the seizure-control drugs made me sleepy. My personality changed with the drugs. I had some other medical problems for which treatment was incompatible with epilepsy.

I tried to carry on as usual but found that I could not. My memory began failing so I carried a tape recorder around my neck. I reorganized my work to compensate, then forgot how I reorganized.

Over the next 3 years, I stopped all outside activity because I was too tired and disoriented. I now know that this was a postictal state because of the seizures. I did not know this at the time. I began blaming everyone and found it more and more difficult to maintain a normal classroom environment. It was exhausting. In January 2001, I began having simple partial seizures several times a day; I was in a persistent, debilitating postictal state and never returned to work.

My finest art work was produced while I was taking a particular seizure medication. My mind worked at a frantic overtime pace.

I have been blaming another seizure drug for my lack of new art work, but as I write this, I realize that my work was linked to my classroom. For 10 years, my classroom was my studio. I produced all my work there and shared production with my students. My motivation came from my students and the loss of my job took it away from me. My depression was also aggravated by this loss and my inability to create new work.

With this in mind, I need to find a dedicated studio space and see what happens.

Putin on the Ritz
Mixed medium
12 x 20 inches

Just Kiss a Pig
Mixed medium
18 x 28 inches

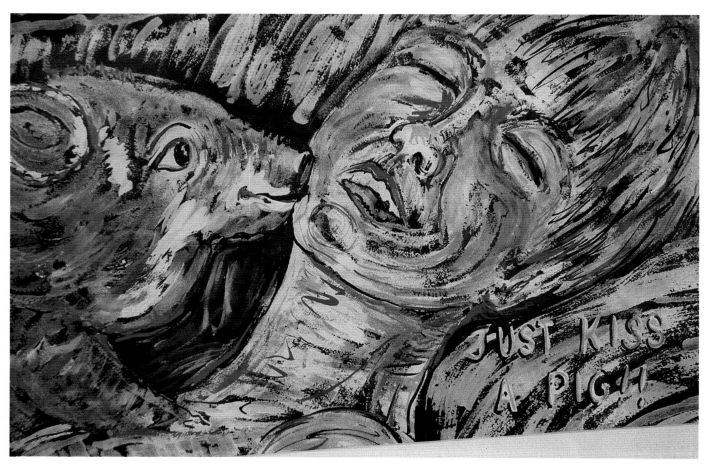

TONI L. LUCAS

I was born in Long Beach, CA in 1960. My father worked for Carnation Can Company and because they often transferred him, I have lived in various states. For the most part I grew up in Mt. Vernon, MO. I started college in Springfield, MO at SMSU. I intended to major in microbiology. After 3 years at SMSU, I moved to Little Rock, AR and finished my college education at UALR. I changed my major from biology to art. In 1985 I graduated with a BA in Art, with an emphasis in illustration. Shortly before I graduated I discovered lithography and I realized immediately that was the form of art I was most interested in.

Two famous people have had great influence on my art. The first was J.R.R. Tolkien who wrote the trilogy *The Lord of the Rings.* Ever since I have read *The Hobbit,* I have been fascinated with dragons and fantasy. The second person was M.C. Escher. I feel that he was one of the most gifted artists that has ever lived.

I was diagnosed with epilepsy when I was 7 years old. Eventually I was told I had temporal lobe epilepsy. Over the years I have tried various medications, but none of them brought my seizures under control. In my mid-20s I began having cluster seizures. My seizures were finally brought under control in 1996 because of two special people, my neurologist, Dr. Victor Biton and my neurosurgeon, Dr. M. Gazi Yasargil. Dr. Biton realized that medication alone would probably never control my seizures and said my only other option was major brain surgery. I agreed to that option. Shortly before my surgery I met Dr. Yasargil. He explained that his method of surgery would leave me without the short-term memory loss that brain surgery usually causes. The surgery was successful. I am still considered epileptic because I still feel the auras, but with medication my seizures remain under control.

I began driving when I was 37, and the only thing greater than that are my two kids, Jeremy who is 14 and Zachary who is 12.

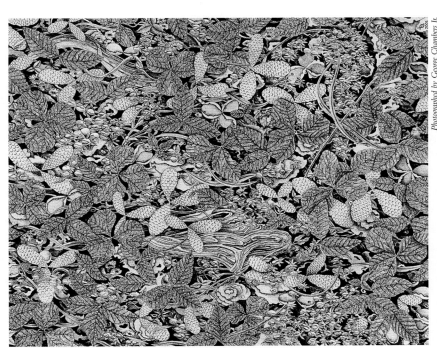

The Forest Floor
2001
Pen and ink
16.5 x 13.5 inches

Photographed by George Chambers Jr.

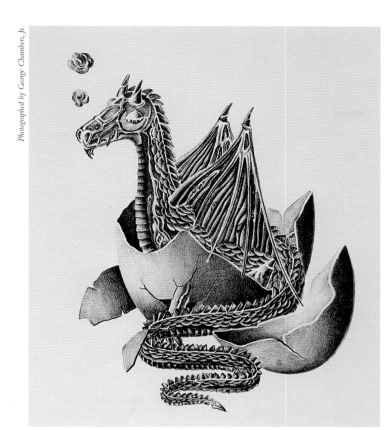

Photographed by George Chambers, Jr.

Finally Free
2002
Lithograph
15 x 13 inches

Formations in the Foundation
1994
Lithograph with color pencil
6.75 x 4.75 inches

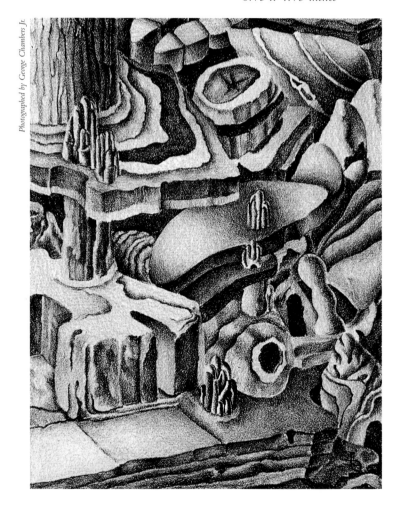

Photographed by George Chambers, Jr.

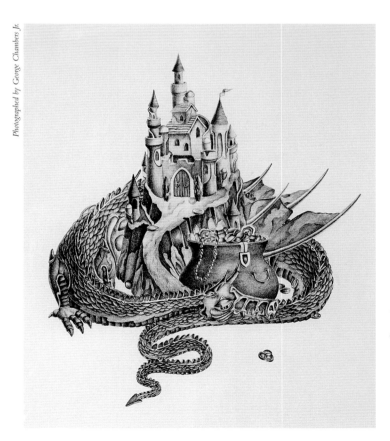

Photographed by George Chambers, Jr.

A Dragon's Delight
2003
Lithograph
15 x 13 inches

DEBORAH MAIALE

My artwork had been part of my life long before my epilepsy arrived. Art has also carried me through many difficult stages as I lived with epilepsy. I am primarily a figure and landscape painter. My work has been exhibited for many years, in a wide variety of competitive shows. Probably my work was influenced by early life in a loving family, in country homes, near lakes and rivers, visiting family farms, climbing trees, building hay forts, traveling in canoes, and camping in forests.

I earned a B.A. in art at Michigan State University, then post-degree studies in drawing, painting, and artists' anatomy at Wayne State University and College of Creative Studies, both in Detroit. Also my work in clay at Pewabic Pottery, Detroit, expanded my sculptural thinking.

However, during the second year after completing my B.A., I experienced a concussion in a head-on collision with a drunk driver. As years went by, the scar tissue grew, my married life began, my first pregnancy brought a healthy daughter, and my seizures appeared. Traumatic adjustments to medication evolved into full control of seizures, pleasant mothering of my little one, and more artwork.

Years taught me that no medication works forever and gradually I went through many. My second daughter arrived healthy also, but received less "fully conscious" mothering. I was fortunate to have a husband who established a business which enabled him to often work out of our home office. Still my painting continued, along with camaraderie among artists' organizations.

After separate stable eras of teaching art in schools without ever having seizures at work, it finally happened. A few months later I began presurgery testing at Henry Ford Hospital in Detroit under Dr. Gregory Barkley. Upon completion I was approved and given brain surgery to remove my scar tissue. To this day (3 years later) I continue medication; but now it consistently works. I gave paintings to my doctors, volunteered and donated artwork to the Epilepsy Foundation of Michigan, and now continue teaching days, painting nights, and giving thanks on Sundays.

My Favorite Pear
1996
Watercolor
9 x 12 inches

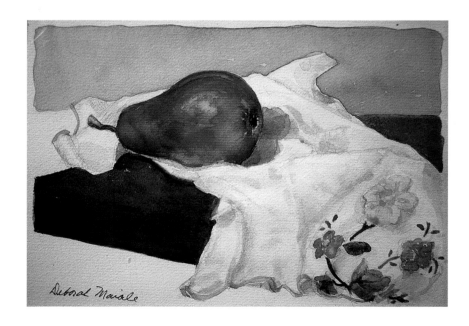

Sleeping Nude
1999
Charcoal
10 x 12 inches

Shanty Creek
Michigan
1998
Watercolor
22 x 30 inches

MAUREEN METZLER

I've been interested in art all of my life. As a kid, I could entertain myself for hours with my little projects. I developed my drawing skills all through high school, and graduated from the art program at Syracuse University in 1997. From there, I moved to San Francisco and worked as an Art Director at a small ad agency. Now back in Massachusetts, I work as a freelance graphic designer, with a wide variety of clients. I've been doing a lot of work for Scout Productions, a TV and Film production company in Boston, creating promotional materials for their productions. I've been lucky to have a lot of creative freedom with my work. By always trying new things, I've been able to grow and develop my talent.

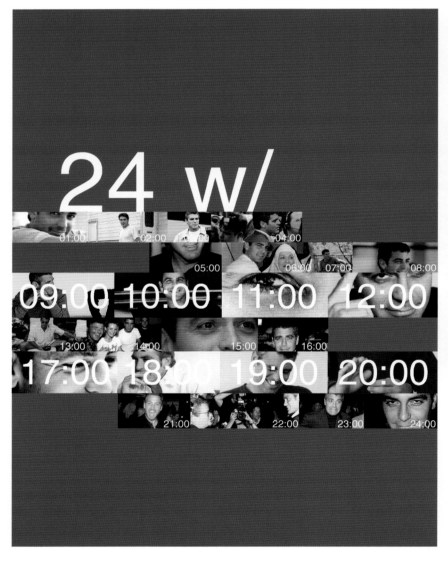

Woman Line Drawing
2003
Digital art
5.5 x 5 inches

24 W/Proposal Cover
2003
Digital art
8 x 10.5 inches

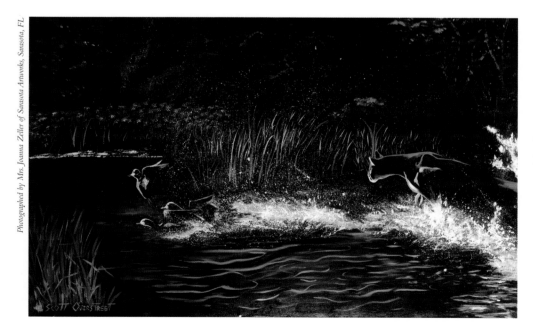

SCOTT OVERSTREET

An Artist who lacks
Self-sufficiency
has not the means
to flourish artistically
nor has the Artist
the ability to indulge
in prolific creativity
thus
the Artist Soul
dies
Inspiration without resource
…fades…

Greetings, I am a self-taught oil painter living with epilepsy, and I have produced original hand-brushed paintings since 1989. I have always had a love of nature and animals which inspired me years ago, at the age of 30, after sustaining a permanent disabling job-related injury, to turn my hand to the art of oil painting.

Through the medium of oil painting, I attempt to try and capture the wild spirit of several of my favorite animals. I also indulge in my artistic creativity to include subject matter other than wildlife, in a variety of styles including, marine, eclectic, abstract, surreal, and humorous.

I am often asked the question, "What motivates you to produce art and music?" My answer is simple, I hope through my artistic expression to stir an emotional reaction in the viewer/listener. If one is having a stressful or bad day, hopefully I can lift the spirit, whether through visual or auditory stimulation.

Photographed by Mrs. Joanna Zeller of Sarasota Artworks, Sarasota, FL.

Instinct for Survival
1998
Oil on canvas
50 x 32 inches

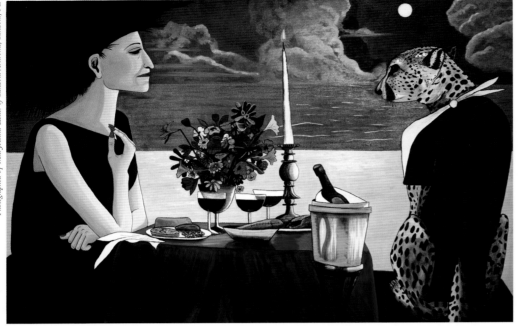

Photographed by Mrs. Joanna Zeller of Sarasota Artworks, Sarasota, FL

Moonlight Dinner Beachside
(Subject of the Missing Brooch)
1994
Oil on canvas
72 x 48 inches

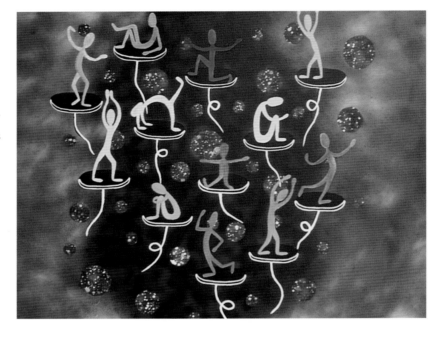

Dream Dancers
1999
Oil on canvas
72 x 48 inches

Fanciful Fish
1995
Oil on canvas
72 x 48 inches

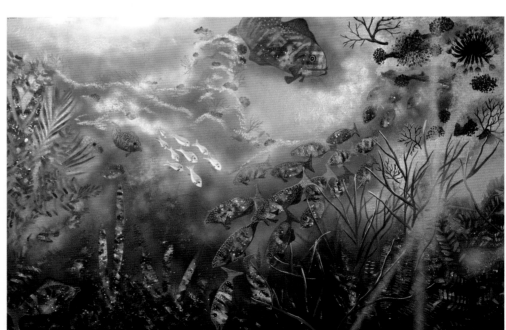

Photographed by Mrs. Joanna Zeller of Sarasota Artworks, Sarasota, FL

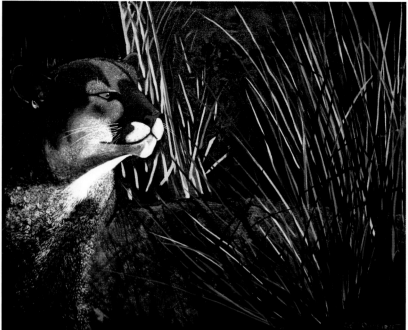

Photographed by Mrs. Joanna Zeller of Sarasota Artworks, Sarasota, FL

Panther in the Reeds
1996
Oil on canvas
48 x 50 inches

Photographed by Mrs. Joanna Zeller of Sarasota Artworks, Sarasota, FL

Licking Branch
1989
Oil on canvas
36 x 25 inches

Until There
is a Cure
1994
Oil on canvas
72 x 48 inches

DOTTY PEDI

I have right temporal lobe epilepsy. After many unsuccessful drug trials in 1998 I had a right temporal lobectomy. Before the surgery took place I was told my artistic talent might possibly not be there postsurgery. I'm happy to say my talent is still here and some say it has actually improved!

I will always be grateful to my doctors—Drs. Cole and Cosgrove—for without their support and "talent" my quality of life would be much different today.

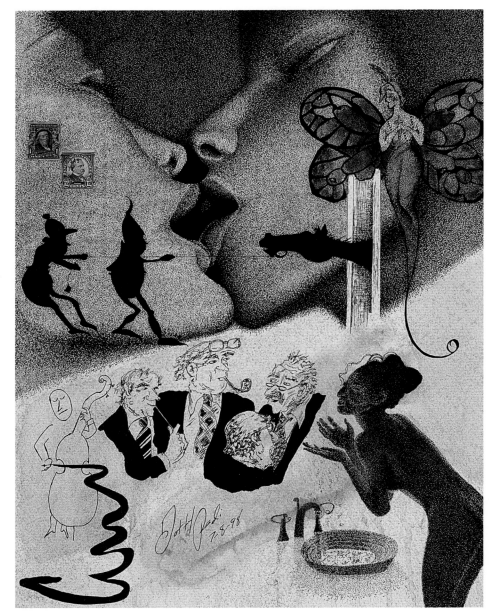

Wandering Thoughts
1998
Ink and watercolor
12 x 14 inches

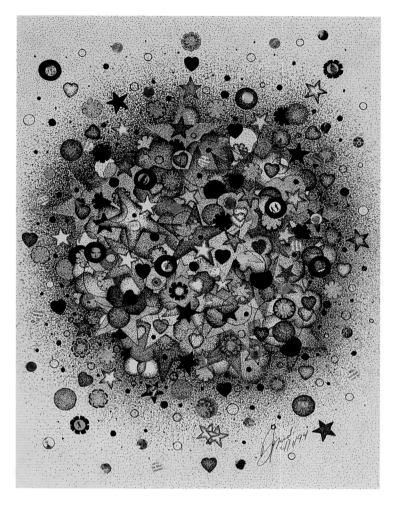

The Kaleidoscope Eye
1994
Ink and punched out paper circles
9 x 12 inches

Red Rose Tea
1995
Ink and stamps (paper)
9 x 12 inches

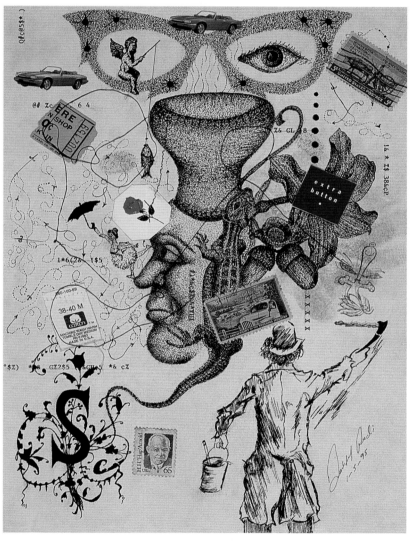

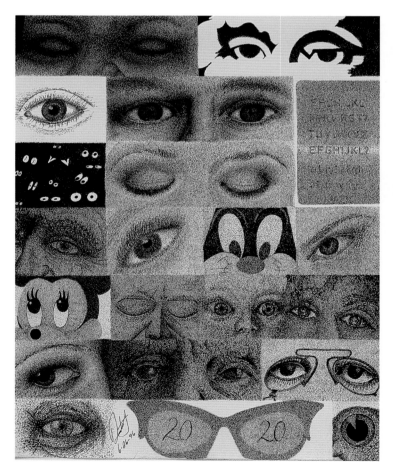

20/20
1996
Ink and watercolor
12 x 14 inches

ANSEL PITCAIRN

I have been living with epilepsy for 20 years now and have not let it prevent me from continuing my pursuits in the visual arts. Attending group meetings and participating in annual exhibits sponsored by the New York Epilepsy Foundation in the early 1990s provided a means to get my work seen by a larger audience and made me realize how many more gifted people living with epilepsy are out there.

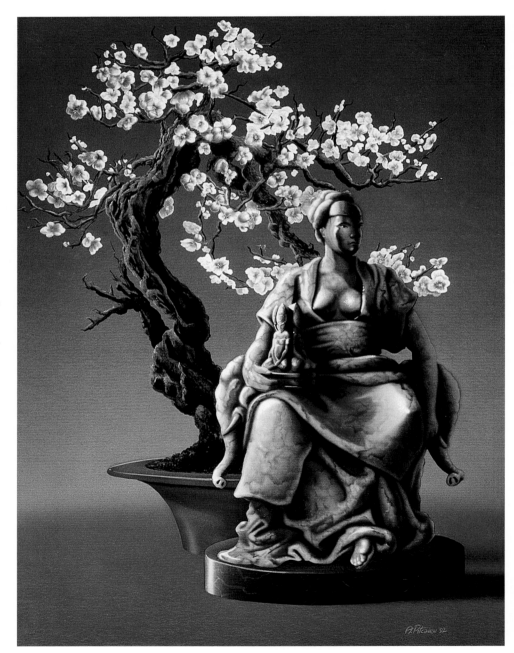

Asia
Acrylic on water paper
20 x 30 inches

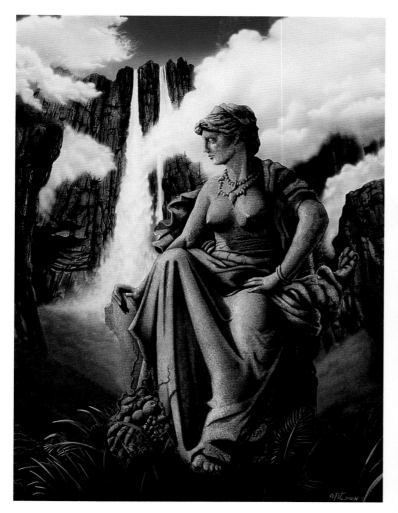

South America
Acrylic on water paper
20 x 30 inches

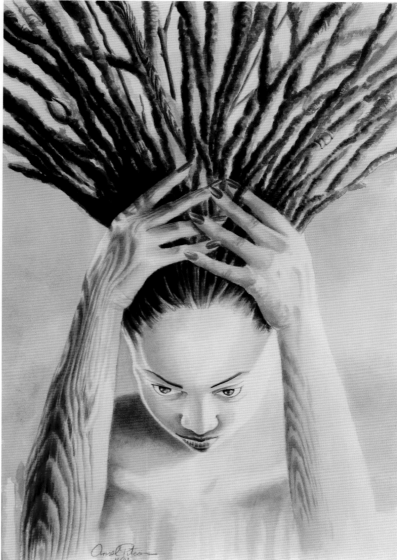

Portrait of Marjorie
1997
Acrylic on water paper
16 x 22 inches

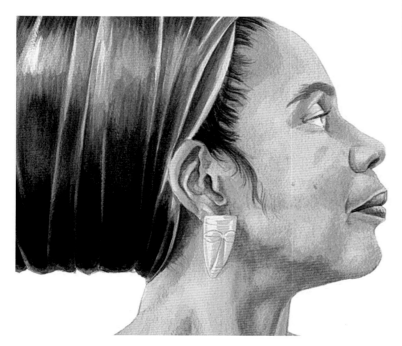

Lorraine
Acrylic

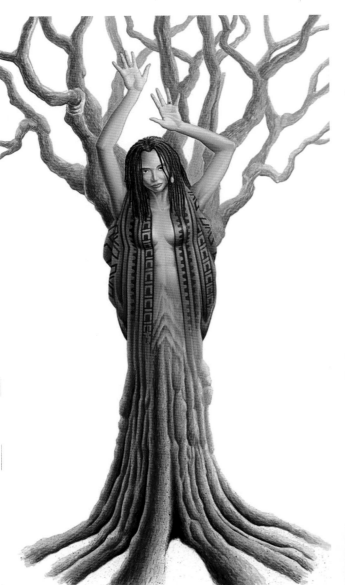

Indigenous
Acrylic

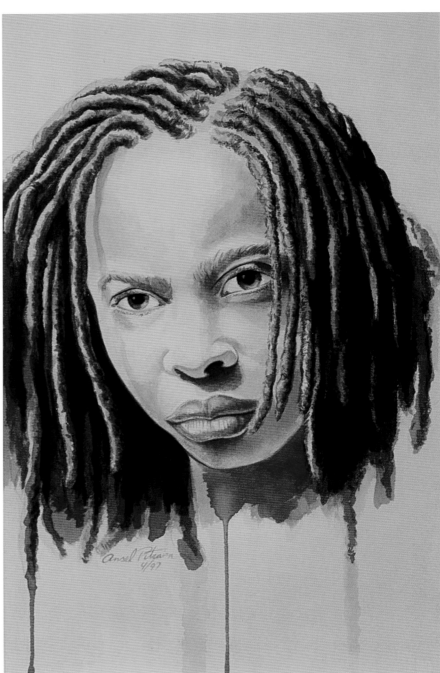

Tracey
Acrylic

56

SIMON POWELL

I was born in January 1958 in England. When I was 10 years old I started to have epileptic seizures. In 1977, when I was 19 years old, I had a brain operation to try and cure my epilepsy. Unfortunately it made it worse and it gave me a surgical stroke. I completed a B.A. Hons in Fine Art at Falmouth School of Art in Cornwall. Since then I have been painting bright colourful paintings. The reason for the colour, I think, has to do with my epilepsy. I know that my paintings cheer people up and probably have a positive influence on my outlook on life. I live by the coast and enjoy painting boats and local town scenes in the west of England.

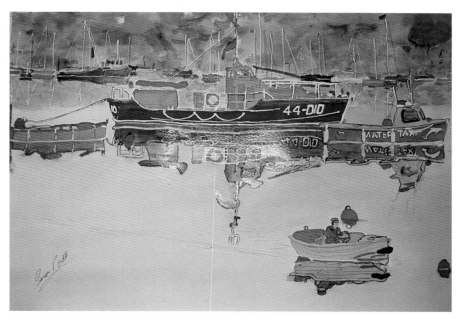

Fowey Lifeboat 44-010
1998
Watercolor
297 x 420 millimeters

Charles Town Harbour
1997
Watercolor
297 x 420 millimeters

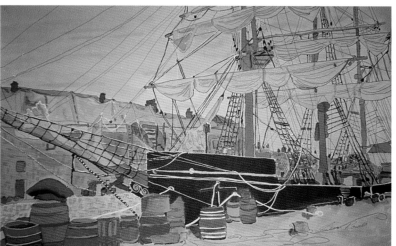

Little Girl in Fore St.
1996
Watercolor
297 x 420 millimeters

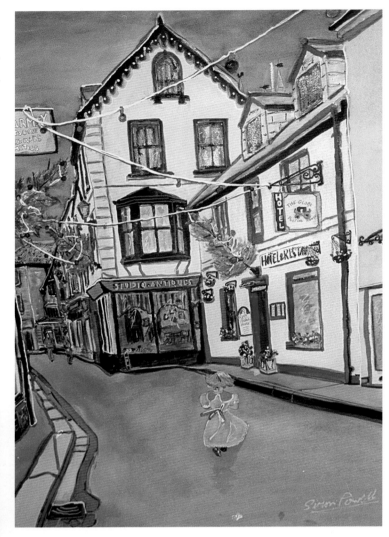

St. Ives Lifeboat
1999
Watercolor
297 x 420 millimeters

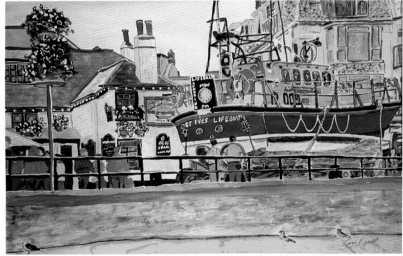

Golant Cornwall in Oils
2001
Oil
841.0 x 420 millimeters

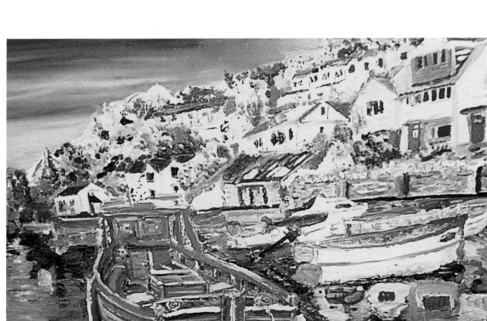

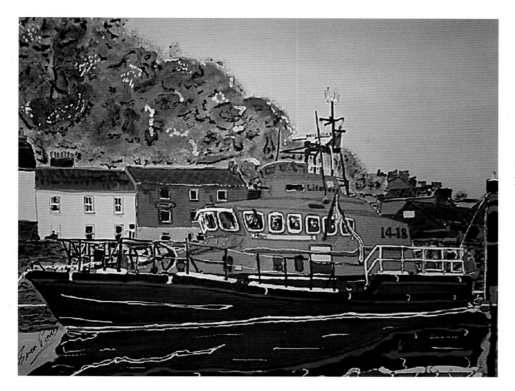

Lifeboat 1418 Fowey Cornwall
2000
Watercolor
297 x 420 millimeters

Plymouth Barbican
Devon Pl 226
1998
Watercolor
297 x 420 millimeters

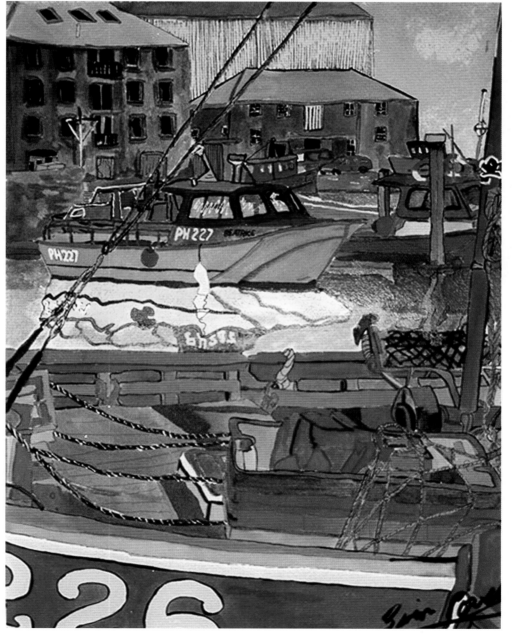

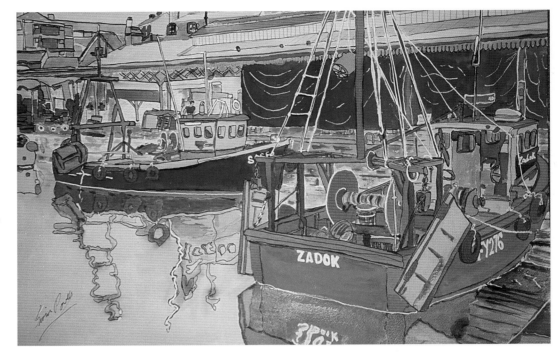

Plymouth Barbican
2000
Watercolor
297 x 420 millimeters

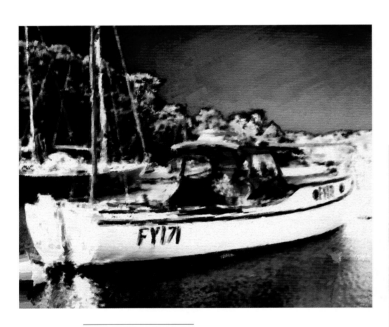

Boat Painted in Oil
2002
Oil
297 x 420 millimeters

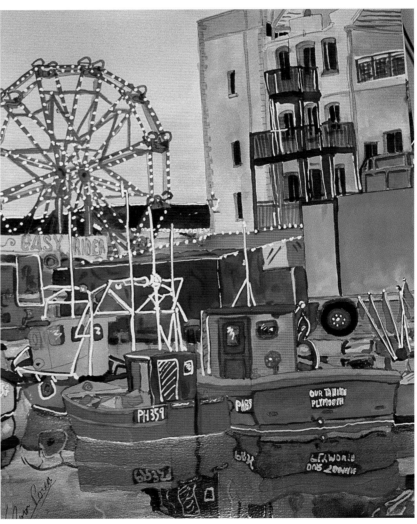

Barbican Fair
1995
Watercolor
297 x 420 millimeters

VOLKER RODERMUND

I was born in 1959 and am married with 5 children. I was educated in pedagogy and work as a caregiver with handicapped youth, including severely mentally retarded people. In "Faces in the Circle," I tried to imagine what a person perceives after slowly recovering from a seizure (like a grand mal seizure with loss of consciousness, resulting in a fall to the ground and lying on the back). I wanted to catch the moment when a person is in between "two states of consciousness"—able to hear, to see, and to smell but still unable to comprehend the situation. And that's the moment to experience "surrealism."

I continue to produce works of art as one way to produce space or rooms where time (or changes) is stopped and where things can be looked at in complete quietness. I move, fly, or float through my pictures.

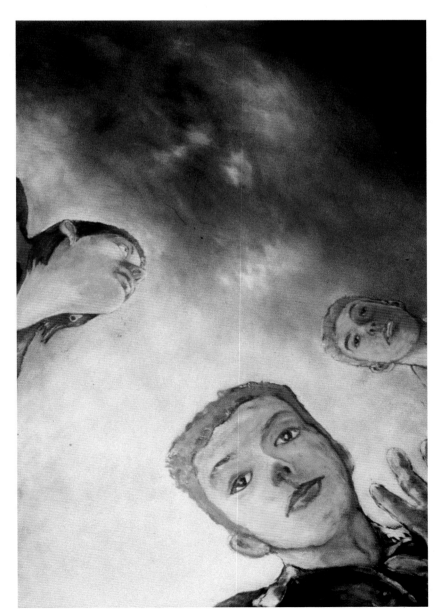

Faces in Circle

CINDY ROSS

*"True Beauty results from the repose which the mind feels when the eye,
the intellect, and the affections are satisfied from
the absence of want."*

I began to make tiles as a hobby about 12 years ago. I was looking for a medium for my artistic expression and recalled fond memories of working in clay as a child. I took various classes at Lill Street Studios in Chicago, and found my passion in Bas-Relief (3 dimensional) tile making. Bas-relief tile making encompasses many of my interests—including the elements of design, sculpture, painting, and color. As well, tiles have an historical context that I find fascinating. I incorporate elements of the context in many of my designs, which also reflect my interests in nature and travel. I rely heavily on inspiration from my garden and the smaller world within the garden. My travels to such places as Asia, the Middle East, and the Mediterranean countries have also provided a wealth of inspiration. Epilepsy for me can be quite unnerving, and so I try to portray a sense of calmness and serenity in my art. However subtle, this portrayal is very satisfying for me as a means to counter my disease. My husband, Stuart, has now joined me in this endeavor and our goal at C-Nik Tiles is to create beautiful, handmade tiles that will last for centuries to come.

The process of making the tiles begins with research and detailed drawings. Using the drawing as a guide I then sculpt the design out of clay. My designs are quite detailed and can take many weeks to complete. The sculpted tiles are then cast in plaster. Porcelain clay is then hand pressed into the molds. We look at these pieces as a painter would a blank canvas. The clay is dried over a period of 2 to 4 weeks, and then bisque fired, during which time many of the designs are altered in an effort to bring back the undercuts or to create a unique looking piece. Each piece is then stained and hand painted. Hand painting is a very difficult process, as the glazes must be applied meticulously and in specific quantities. The difficulty with the glazes we use is also because they are "gritty" and therefore do not flow onto dry clay anywhere as easily as oil paint would flow onto a canvas. We are also proud of the fact that most of our glazes are our own recipes, something that takes a lot of time to develop. Finally the tiles are fired to cone 10 (2350 degrees) in a reduction environment for 12 to 14 hours to fully mature the porcelain. A slow cooling process of 2 to 3 days is required. It is always exciting to finally open the kiln 3 days after the firing began and marvel over the results!

The Bouquet
2001
Ceramic tile
12 x 12 inches

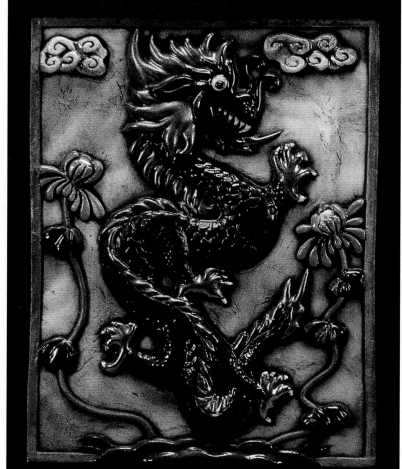

The Black Dragon
Ceramic tile
2002
6 x 8 inches

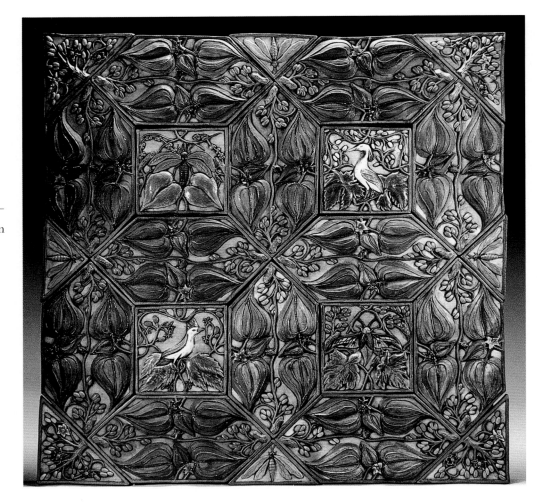

Garden of Eden
1997
Ceramic tile
25 x 25 inches

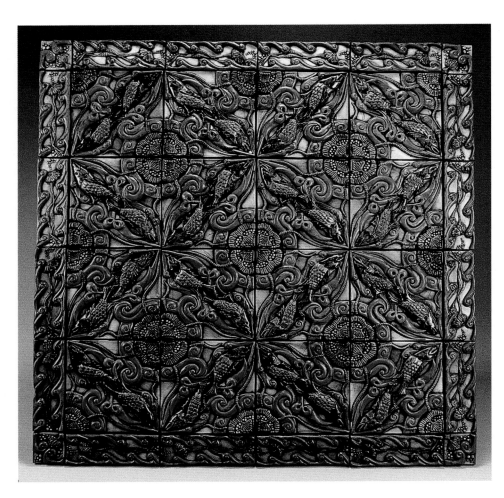

Under the Sea
2000
Ceramic tile
28 x 28 inches

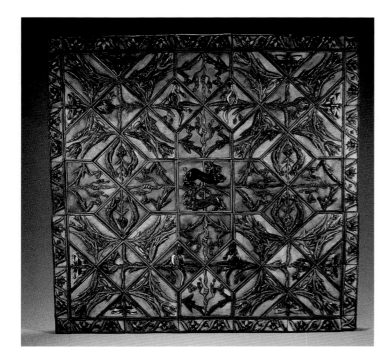

The Turkish Garden
1996
Ceramic tile
33 x 33 inches

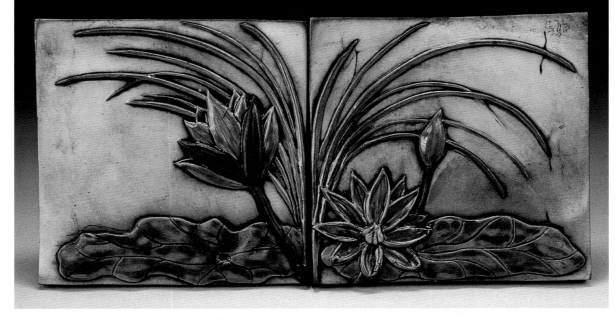

Lily
2002
Ceramic tile
6 x 12 inches

The Dueling Dragonflies
2000
Ceramic tile
28 x 28 inches

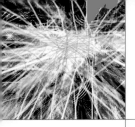

JUDE ROUSLIN

As an artist, my first choice of medium has always been oils, which I began as a child. I have worked in inks, watercolor, acrylics, and various mixed mediums. I feel most comfortable with abstract compositions. I am a relative newcomer to the world of computerized art. During the early 1990s, my seizure disorder worsened, which ultimately impacted upon my ability to continue in my preferred medium, oils. Artistically frustrated, I eventually began the difficult transition from canvas works to digitized art forms. This proved to be a rather long intense process, as I had virtually no prior computer experience and the use of a computer also has the potential to further increase my seizures.

Though I feel that I will never be able to reproduce the textures and depths achieved with oils, I continue to work towards a satisfactory middle. Computerized graphics filled the once temporary creative void and continues to provide challenges that are both exciting and frustrating at times.

I continually strive to visually depict my own seizure-related experiences, unlocking what is neurologically experienced on the inside to the outside. This, in essence, further helps me to gain a better understanding and define what it means to be an individual with an intractable multifocal seizure disorder.

I continue to create with oils and have also continued with digital computerized designs as well. While many works may project a neurological emphasis, these remain largely within digital art forms.

Tile Collage
1998
Color pencil on clay tile
(computer enhancement)
6 x 6 inches

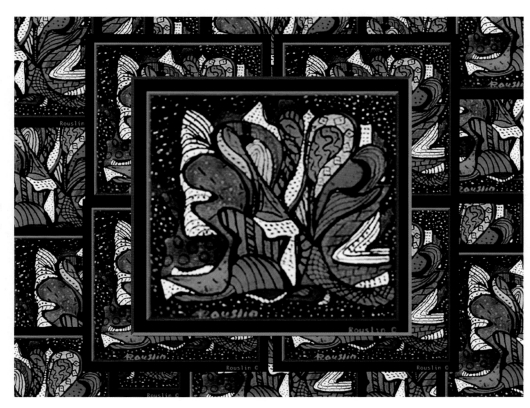

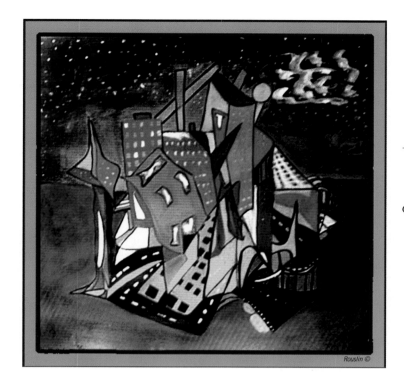

City on Tile
1998
Color pencil on clay tile
12 x 12 inches

911 (NYC)
2001
Computer generated
8.5 x 11 inches

Eucharist
1998
Computer generated
8.5 x 11 inches

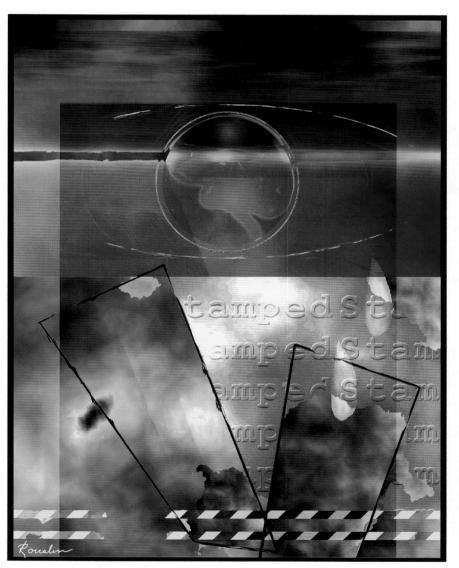

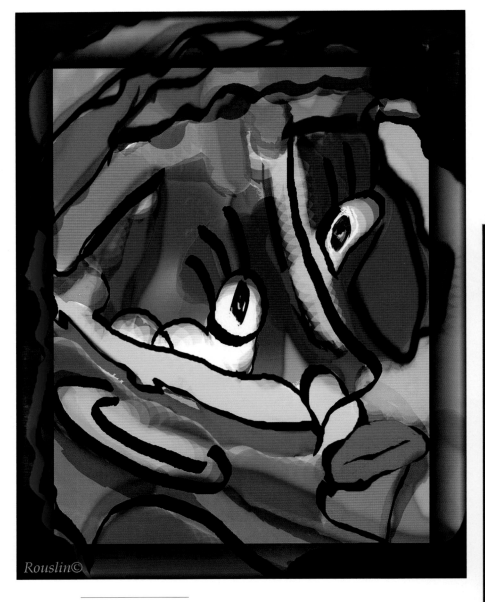

May Abstract
2000 (?)
Computer generated
8.5 x 11 inches

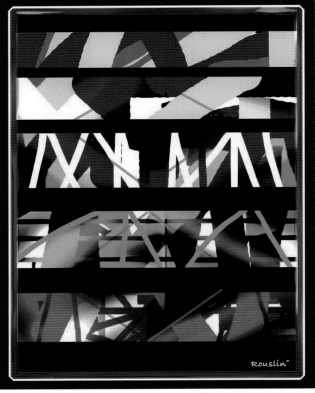

Abstract Face
2001
Computer generated
8.5 x 11 inches

Sidewalk Cafe
1998
Oil
24 x 36 inches

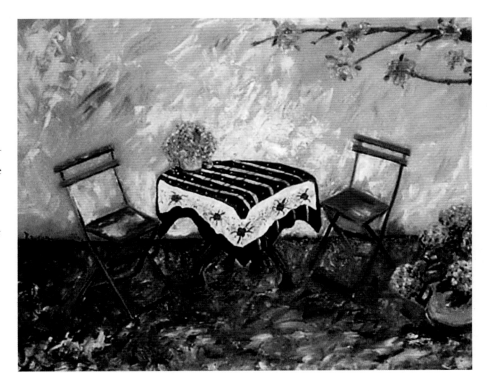

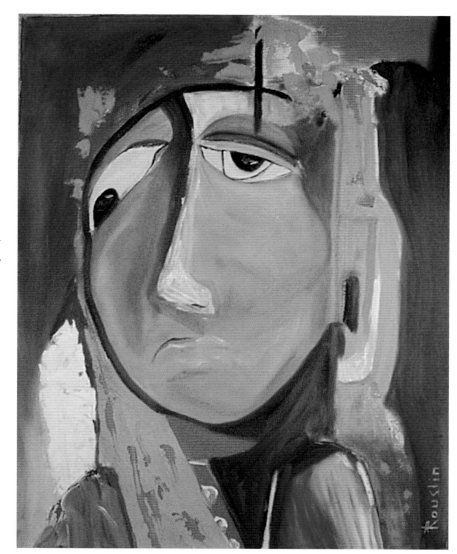

Statue of Liberty
2000
Oil
16 x 20 inches

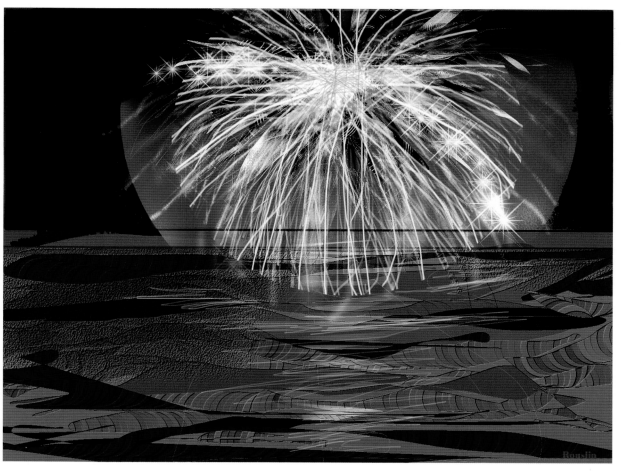

Fireworks
2000 (?)
Computer generated
11 x 8.5 inches

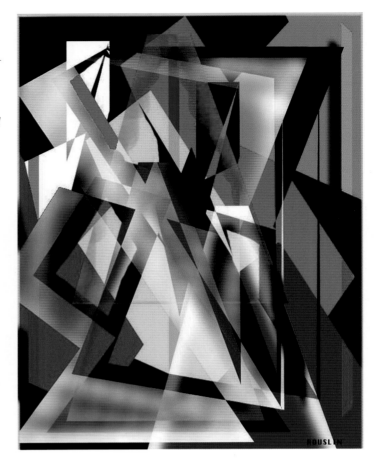

Abstract No. 4
1998
Computer generated
8.5 x 11 inches

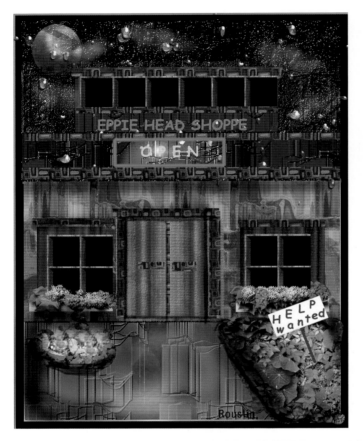

Eppie Headshoppe
1999
Computer generated
8.5 x 11 inches

Palm Tree
1998
Watercolor
6 x 7 inches

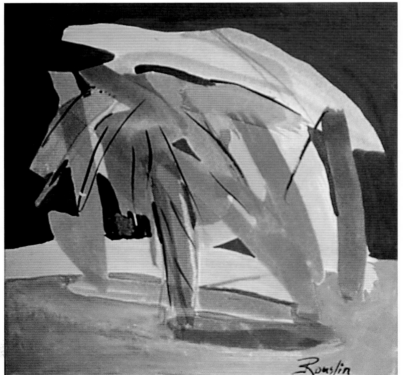

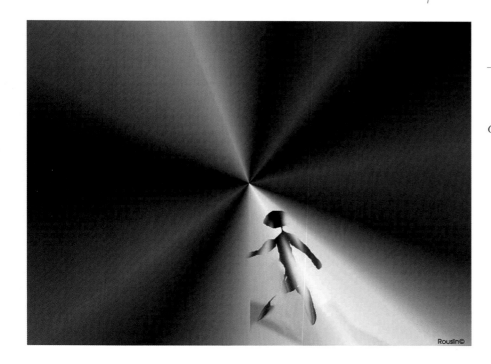

Grey Abstract
1999
Computer generated
8.5 x 11 inches

Flowers In Vase
1999
Computer generated
8.5 x 11 inches

Falling Up the Stairs
1998
Computer generated
8.5 x 11 inches

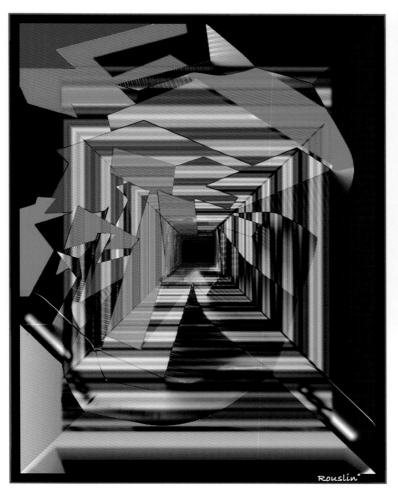

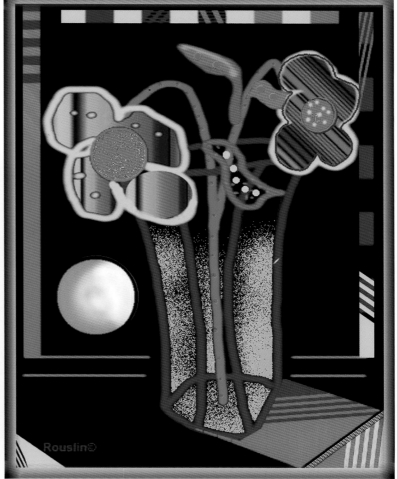

ALEXANDRA ROZENMAN

I was already an artist when my epilepsy came. I needed to find the way around it. I needed to win. First it was just an illness that I refused with all my might, but that happened to be impossible, because "a cage went in search of a bird" (Franz Kafka, *Third Octavo Notebook*).

Sudden fear took me. I found a way to escape into my painted land of symbols and fairytales. From then on I often blessed it. To find strength and passion for a constant fight with fear and danger I had to believe in miracles. I did and still do. It is a gleam of what, in my eyes, constitutes the essence of the true artist: the strange alliance of the passion to create a deep humility.

The magic in my work is a bird flying away from the cage.

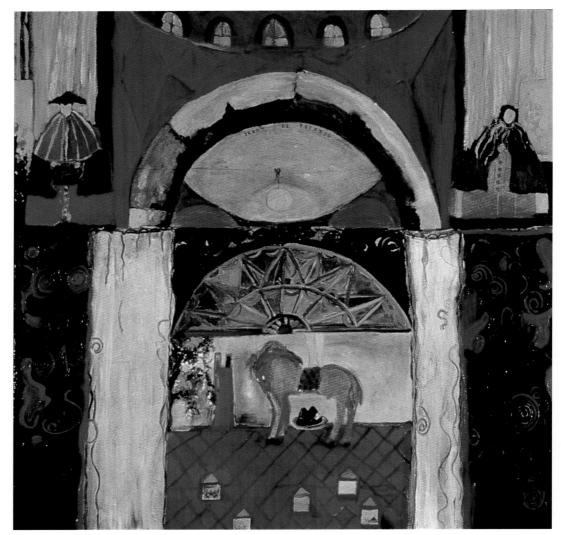

Octaves du Passe
1997
Oil on canvas
52 x 53 inches

Photographed by Dana Salvo

Photographed by Dana Salvo

May I Move In?
1999
Oil on canvas
16 x 16 inches

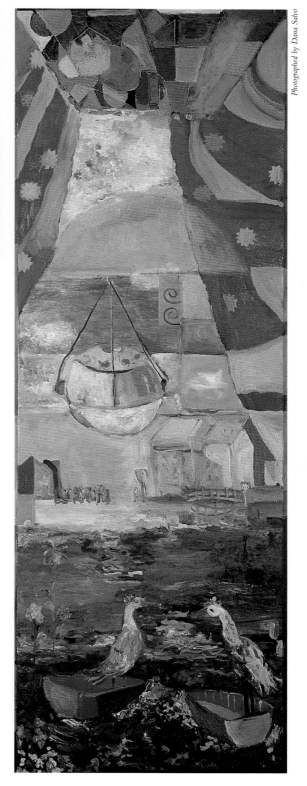

Claude Monet Taking a Shower
1996
Oil on canvas
60 x 60 inches

How Do You Fly?
1998
Oil on Canvas
24 x 72 inches

Photographed by Dana Salvo

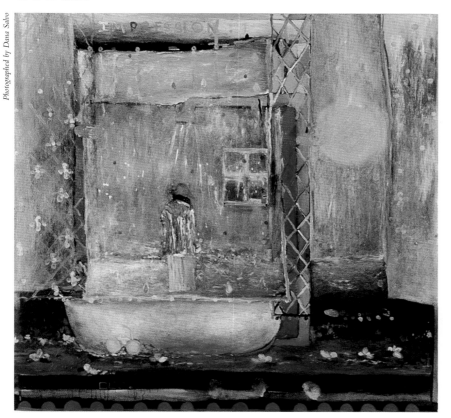

Photographed by Dana Salvo

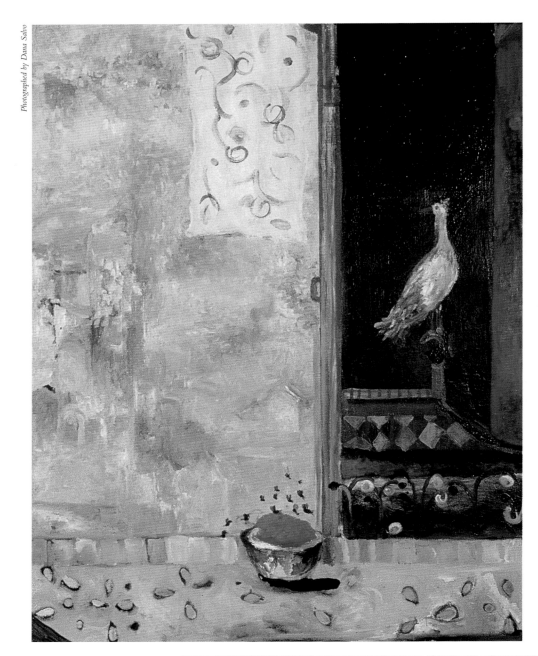

Forgotten Jam
1999
Oil on canvas
30 x 40 inches

Date With the Wind
1998
Oil on canvas
40 x 30 inches

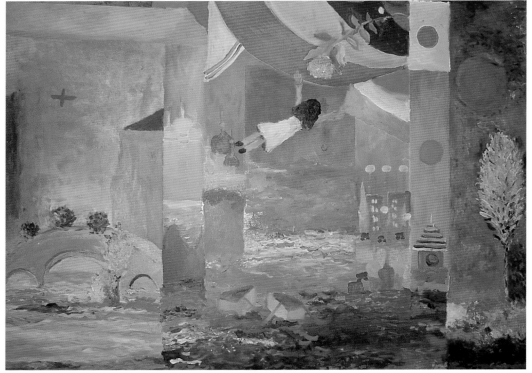

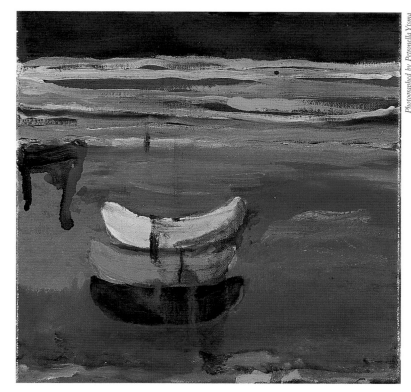

Photographed by Petronella Ytsma

Three Ways
2002
Oil on canvas
12 x 12 inches

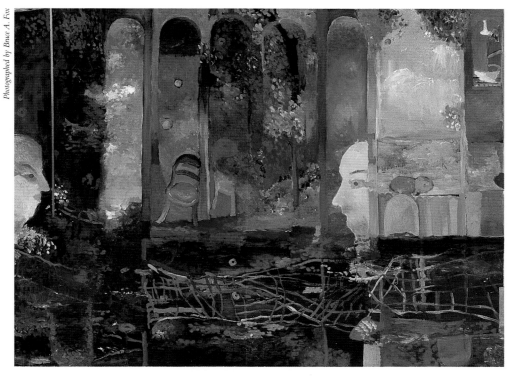

Photographed by Bruce A. Fox

Two Brothers
2001
Oil on canvas
48 x 36 inches

Replenishment
1998
Oil on canvas
60 x 20 inches

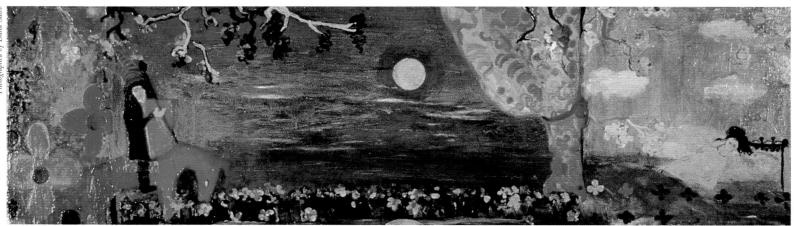

Photographed by Dana Salvo

Photographed by Petronella Yisma

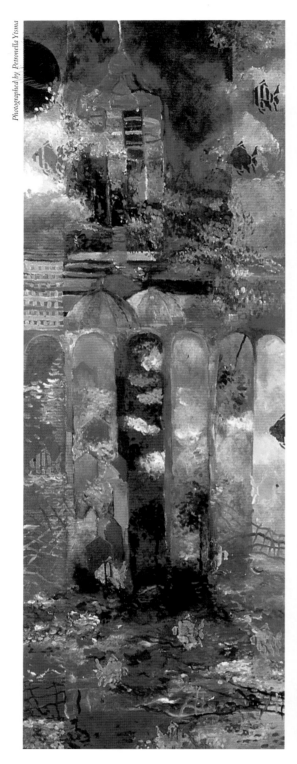

Photographed by Dana Salvo

Let's Hold Our Breath
2000
Oil on canvas
24 x72 inches

Sisters
1997
Oil on canvas
9 x 20 inches

Photographed by Dana Salvo

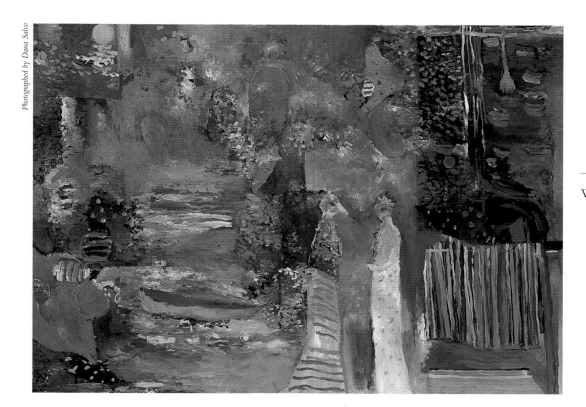

When They Met
2002
Oil on canvas
65 x 48 inches

Photographed by Petronella Ytsma

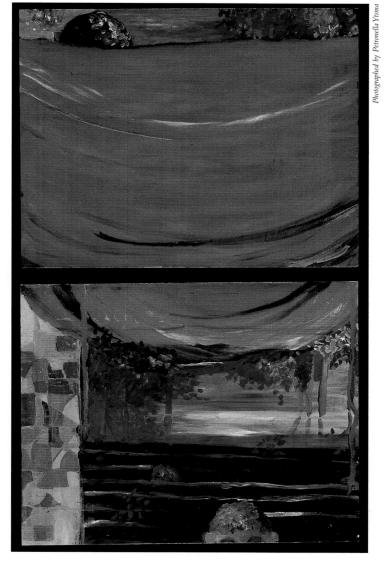

Long Red Sleeves
Oil on boards
20 x 33 inches

Insomnia
2002
Oil on canvas
9 x 9 inches

Photographed by Petronella Ytsma

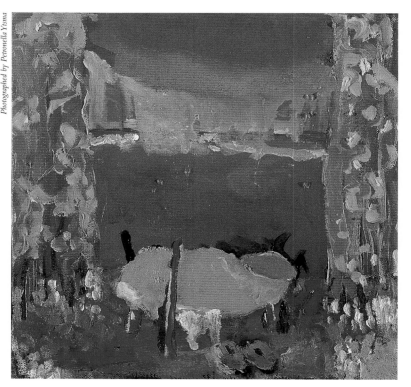

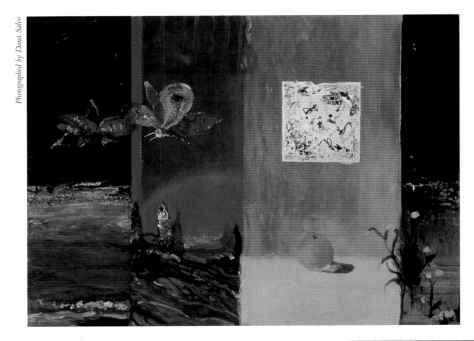

Photographed by Dana Salvo

Enter Around the Corner
1999
Oil on canvas
40 x 30 inches

First Wife
2002
Oil on canvas
20 x 16 inches

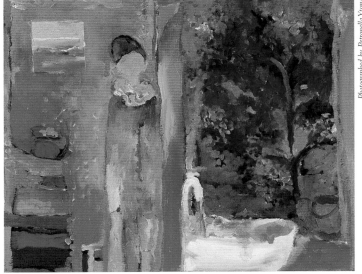

Photographed by Petronella Ytsma

Closing Act
2001
Oil on canvas
60 x 48 inches

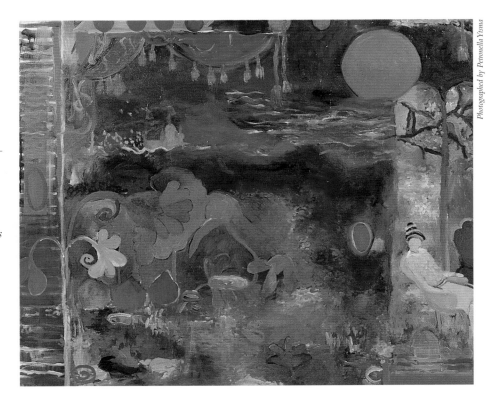

Photographed by Petronella Ytsma

JON SCHROCK

I was born in Jos, Nigeria and lived the first 5 years of my life in Africa. After returning to the United States for several years we went back to Africa in the early 1980s, this time to the Sudan. We lived in a very remote part of the country without many amenities or luxuries. And with the adaptability that all kids have I learned to enjoy and cherish the simple but strong community-centered lifestyle. My cross-cultural experiences have led to an interest in Islamic geometric design and the starkness of many African landscapes.

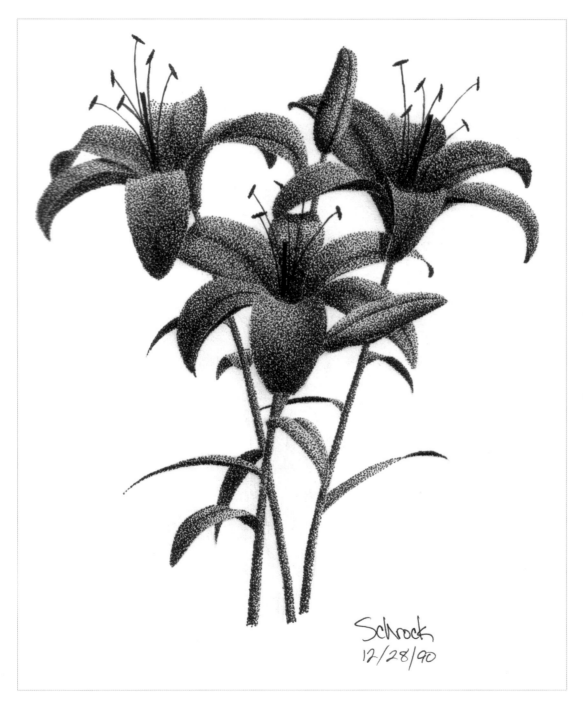

Flowers
1990
Ink
8 x 10 inches

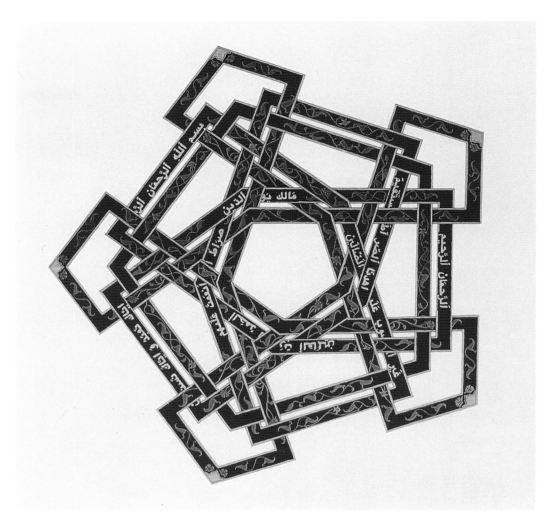

Untitled Pentagon
1993
Tempera paint
16 x 16 inches

Horizon
1990
Ink
20 x 6 inches

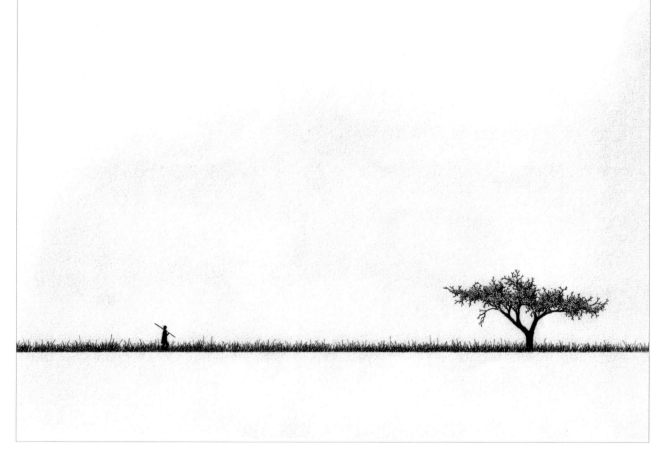

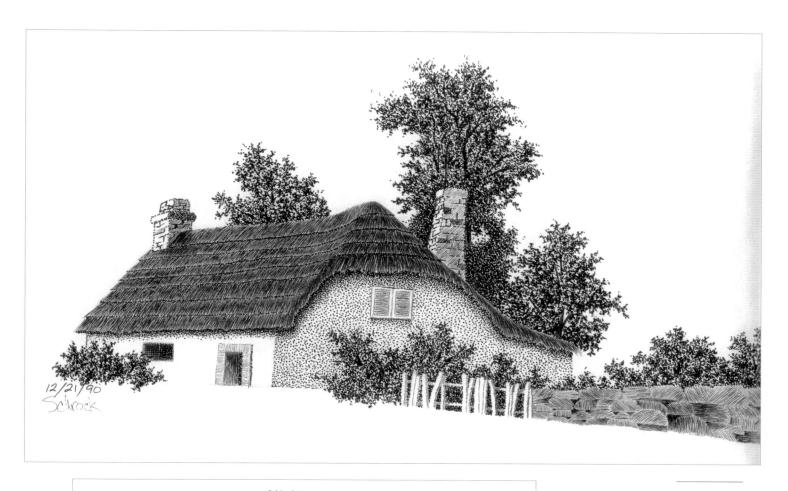

House
1990
Ink
16 x 8 inches

Frustration
1991
Ink
10 x 12 inches

STEVEN V. SOMMOVIGO

Steven V. Sommovigo is a native Virginian. He has studied art at the University of Virginia and private instructors, focusing on both graphic and fine arts. He designs logos and develops brochures for private and corporate business. In the fine arts area, he works in watercolor, pastel, and mixed media.

Mr. Sommovigo has participated in group shows and in individual shows including the McLean Project for the Arts, The University of Virginia and the Emerson Gallery. His mixed media works have been displayed by corporate calendars and the national magazine, *Quilter's Newsletter Magazine.*

He originally was employed in the commodities industry; but upon the onset of epilepsy, has relied on his care for the fine arts.

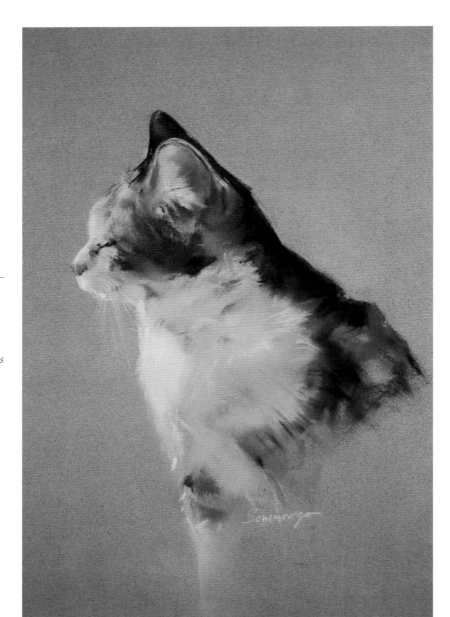

Cat Profile
2003
Pastel
10 x 7 inches

Coke Can Quilt
2001
Aluminum
48 x 36 inches

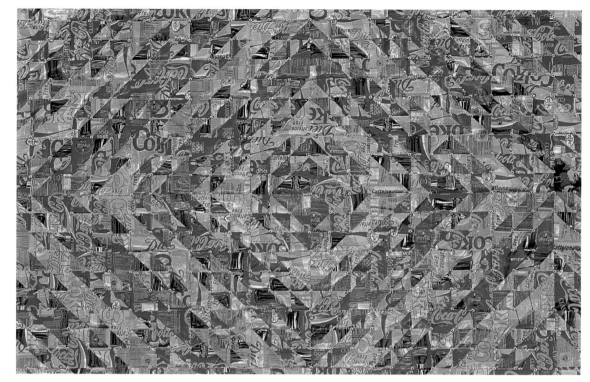

Calvin Run Mill
2000
Watercolor
22 x 16 inches

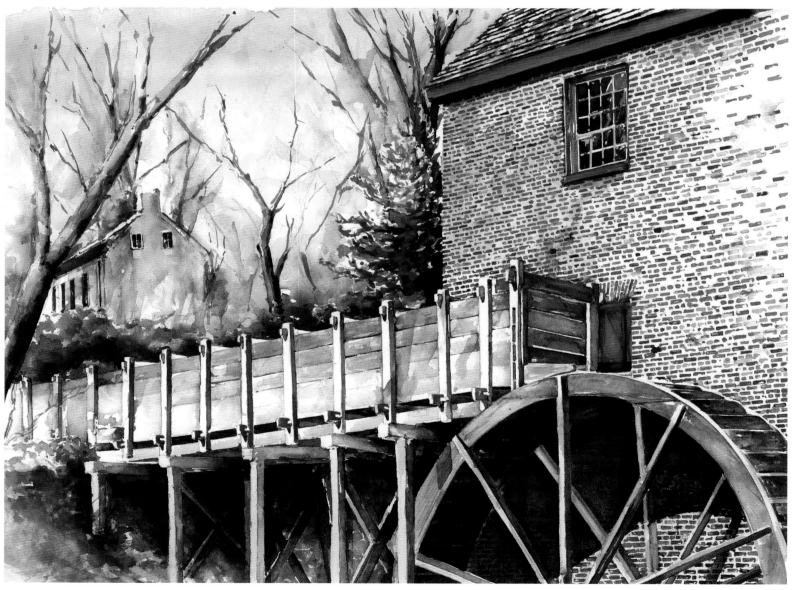

Golden Retriever
2002
Pastel
10 x 12 inches

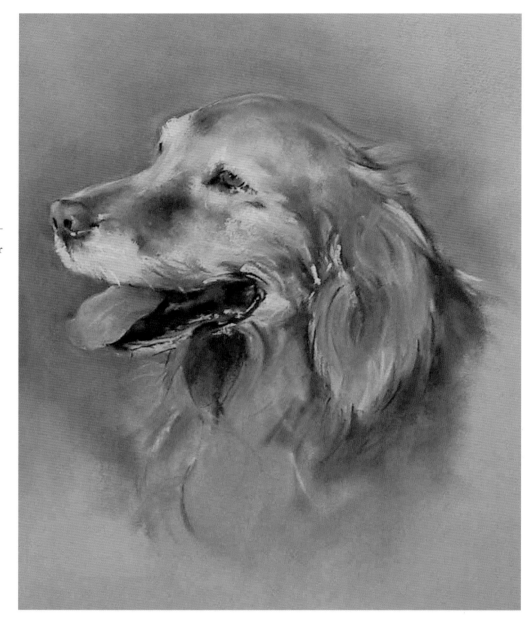

Untitled Aluminum
Can Quilt
2000
Aluminum and wood
72 x 48 inches

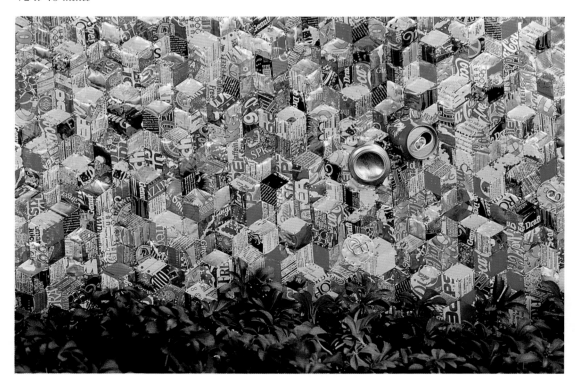

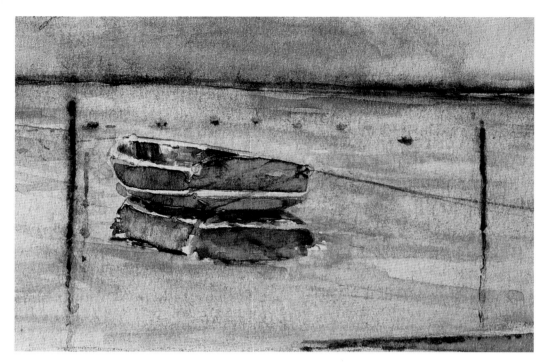

Reflection
2000
Watercolor
8 x 6 inches

Tonkinese
2002
Pastel
10 x 12 inches

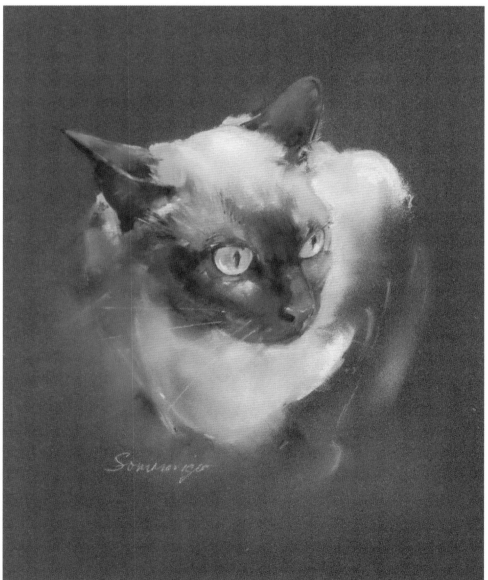

JACQUI STREETON

A fter I was diagnosed with epilepsy, I learned all I could about the disorder. I realized that I had a responsibility, after slowly regaining my artistic abilities, to educate others about this illness "through the eyes instead of the ears."

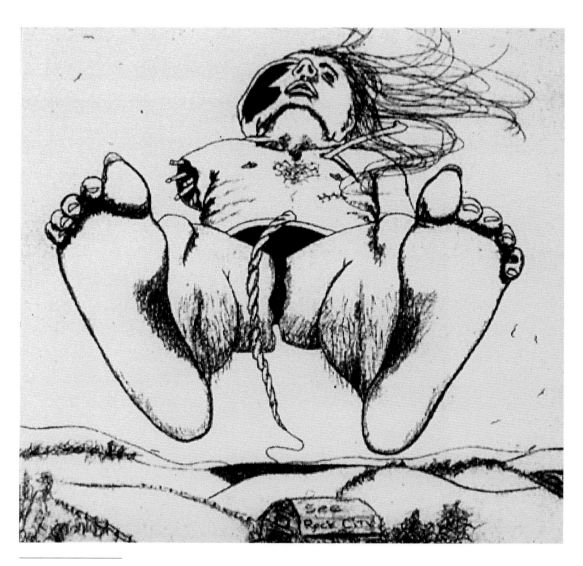

Postictal

1993

Ink (watercolor wash)

14 x 14 inches

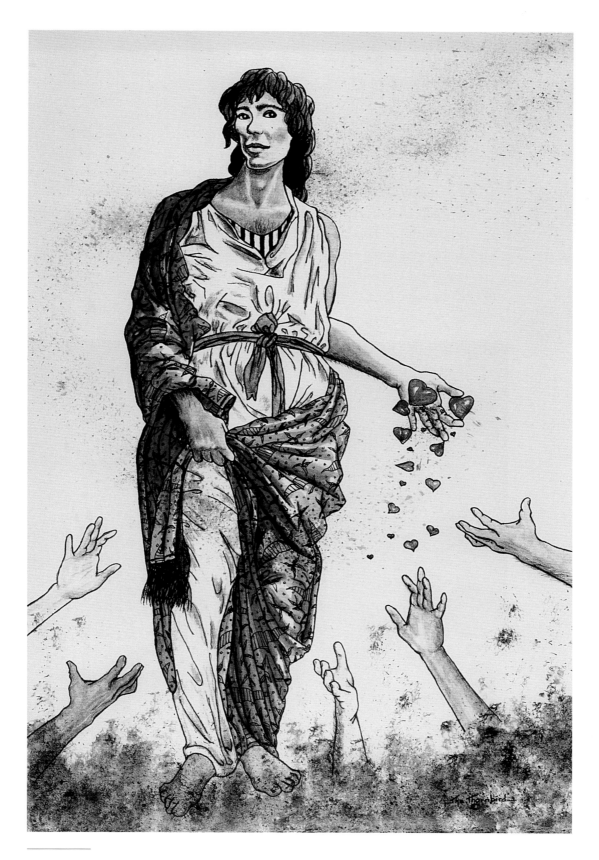

St. Valentine

1993

Watercolor

HOWARD SWIEL

Epilepsy came to me suddenly in Lausanne and my wife encouraged me to see a doctor. The brain operation to stop my seizures went ahead in 1999 with great success and since then I have had no seizures. Memory and concentrating are small problems for me.

Photography is my manner of expression and I enjoy following it through.

By walking I see something different; figures that move in light. I must catch the figures, and catching something in difficult light can be a challenge as well.

At the Wrestling
Competition
Nyor 2001
Photograph

Turkey
Istanbul 1995
Photograph

Cape Town
1998
Photograph

Selling Spray in Lausanne
at One of the Festivals
Photograph

Port Elizabeth
South Africa 1984
Photograph

DAVID THINGER

I successfully worked in computer graphics for 10 years until my accident in '92. I've been disabled ever since then because of my seizures, memory loss, and unsuccessful brain surgery in '94 which was extremely difficult to go through. Despite these difficult happenings I've gone through, art has been a major factor in my accepting my condition and loving myself the way I am. It has actually been more difficult accepting the fact that I can't work, than accepting my medical condition. I feel my fine art quality is far stronger ever since my seizures came back and left me disabled. This definitely interests me because artists such as Leonardo Da Vinci, Michaelangelo, Van Gogh and many others also had seizures.

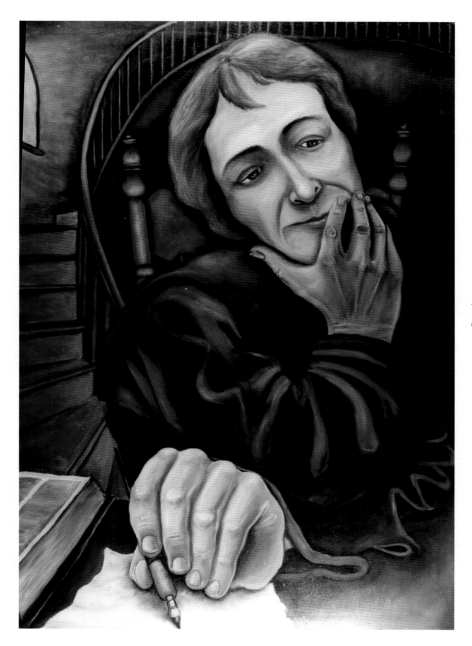

Creative Concentration
Oil
48 x 36 inches

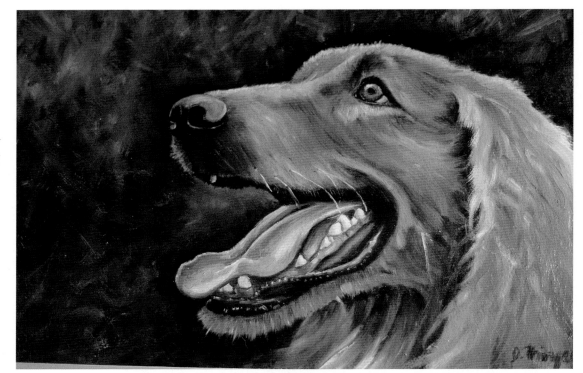

Untitled (Portrait of
Golden Retriever)

Fruit and Wine
Oil
18 x 24 inches

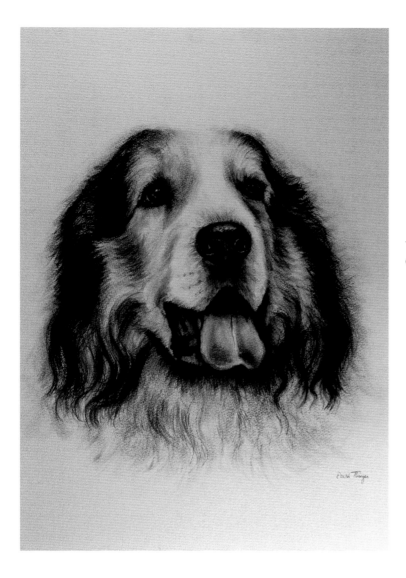

Great Pyrenase
Smile
Charcoal
24 x 18 inches

Our Portrait of Love
Charcoal
18 x 24 inches

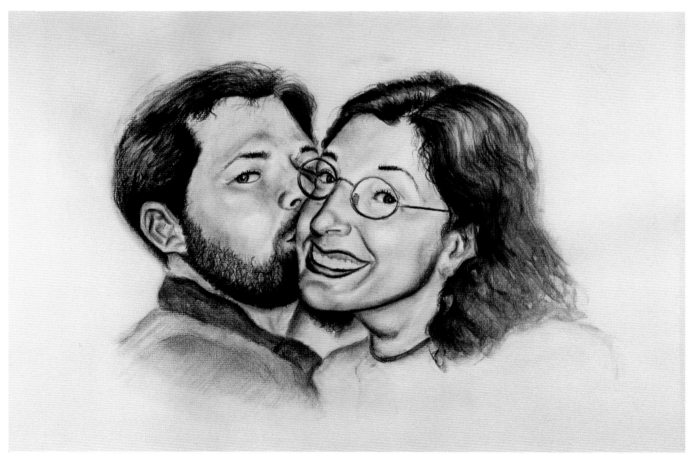

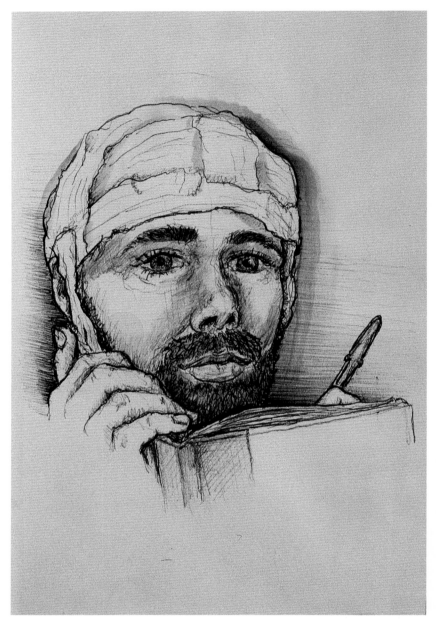

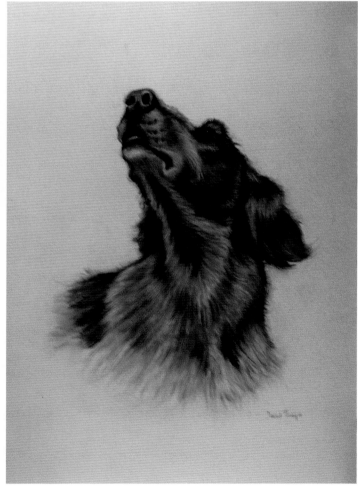

Self Portrait After Surgery
6 x 9 inches

Howling for Joy
Pastel
24 x 18 inches

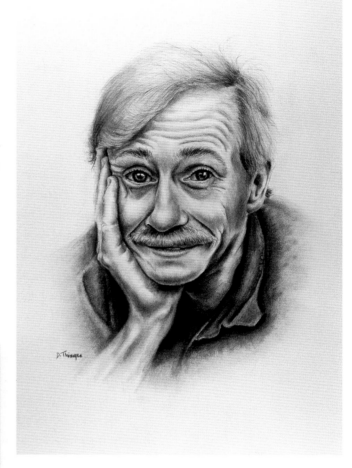

Hand on Chin Pose
Charcoal
24 x 18 inches

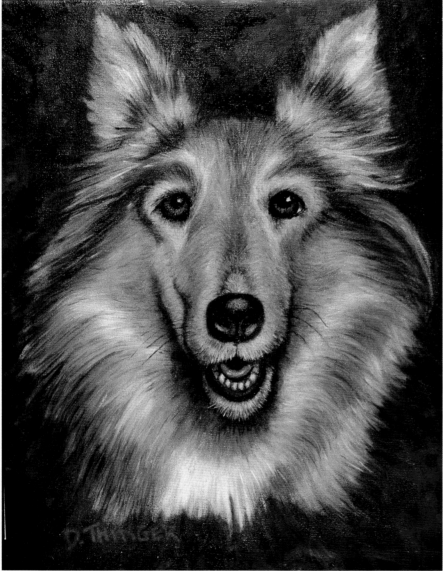

Collie Portrait
Oil
24 x 18 inches

KLAAS VERBOOM

At 6 years old, epilepsy entered into my world when my twin brother had a grand mal seizure, leaving my parents, older brother, kid sister, and I totally bewildered. Over the years, he had hit the floor so many times that the back of his skull smashed to little pieces, causing him severe brain damage. We helplessly watched as his head slowly puffed up from drugs until one day when he was 13 or so, he had to be institutionalized for full-time care. It was awful, unfair, and unexplainable. I think the sadness of it all strengthened the family bond and appreciation for life and good health.

On the first day of high school, in the crowded hallway, I tried to remember the combination to my locker. As I focused on the numbers, white space gradually emerged into the ceiling of a different room, and a voice informed me that I had passed out. I had a grand mal seizure. The mysterious boogieman had his grasp on me and could slam me down and rattle me without regard for pain or situation.

Because of my preconception of epilepsy, my future was doomed. I had no say over the matter; it simply was a question of "when?" Self-pity and anger would sneak in to visit fear, and it was in drawing that I could consistently depend on to find peace. It was where I regained control and I had the last say. Hours of work felt like minutes of play and if time was limited, that's how I wanted to use it.

Even though the valid fears of the past have been proven wrong, crowded rooms still feel uncomfortable. Over the years, whenever I find myself asking "what if…?" I've learned to replace it with "what if not ….?" Success seems to be measured more by hours of painting and good health than anything else.

Thanks to all those concerned in the medical sciences, I am fortunate that I'm loved by family and friends and that epilepsy is not the negative demon I once thought it was, but a condition that carries no shame or embarrassment. After all, it did help my work find its way onto the pages of this book.

Photographed by André Nujer

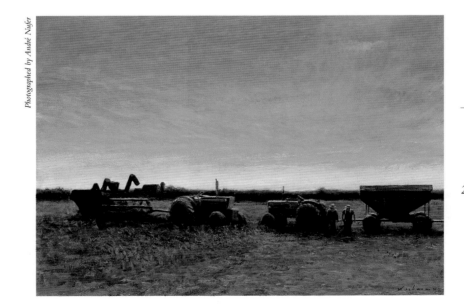

Harvest
1990
Oil on paper
22 x 34 inches

Photographed by André Nüfer

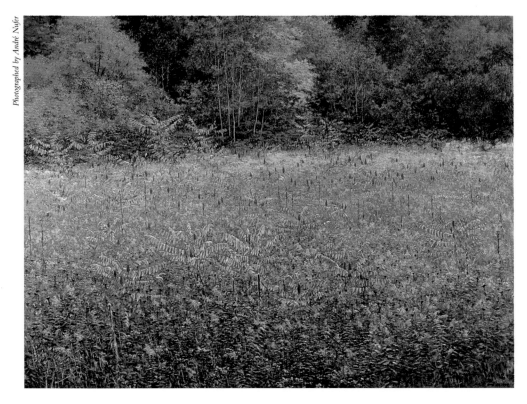

Springtime
2000
Acrylic
16 x 20 inches

Photographed by André Nüfer

Round Bales
2000
Oil on canvas
12 x 12 inches

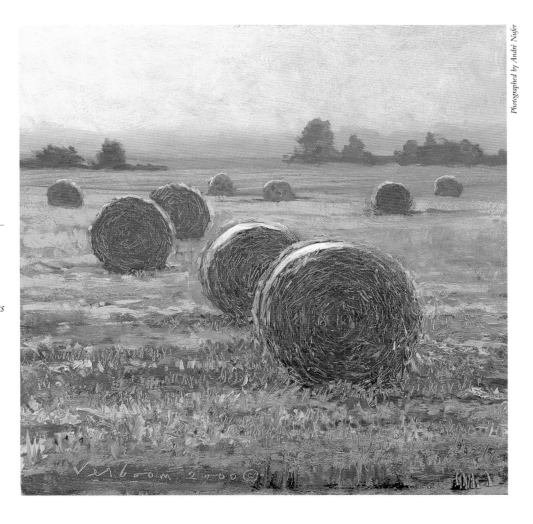

Photographed by André Nifer

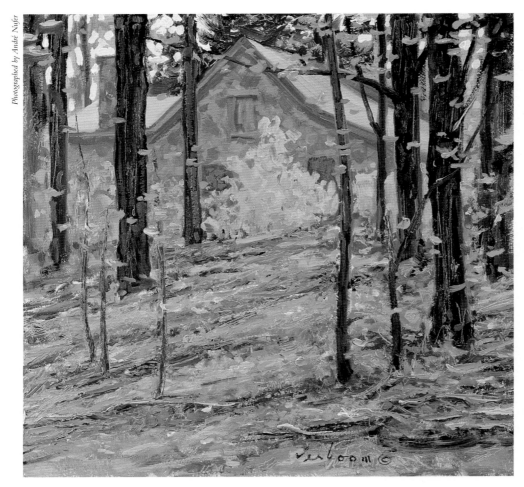

Cottage in the Woods
2000
Oil on board
12 x 12 inches

Photographed by André Nifer

Road in the Woods
2000
Oil on board
12 x 12 inches

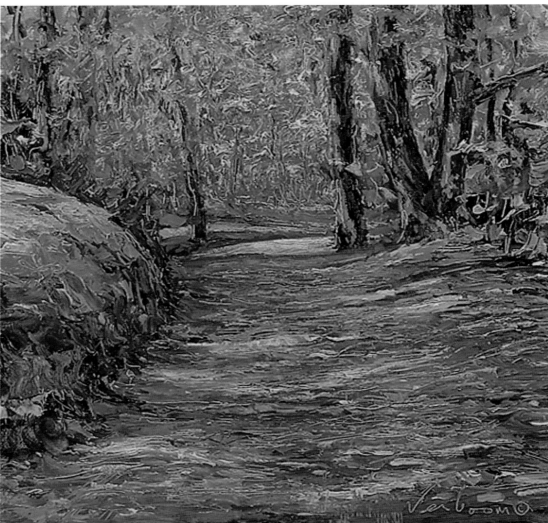

Photographed by André Nufer

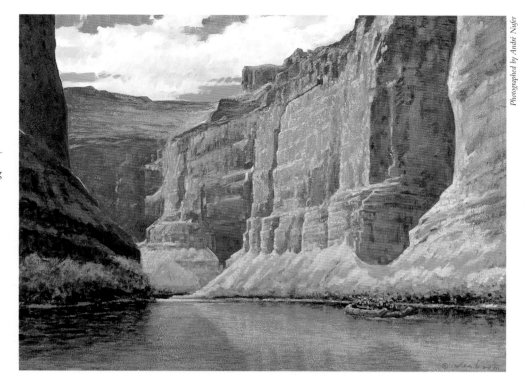

Canyon Rafting
1992
Oil on paper
24 x 32 inches

Photographed by André Nufer

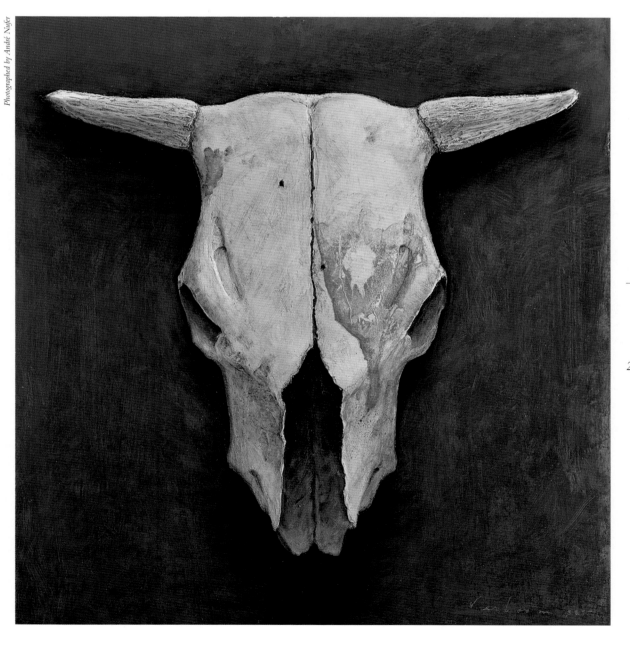

Bull's Eye
1989
Oil on board
22 x 20 inches

Photographed by André Nüfer

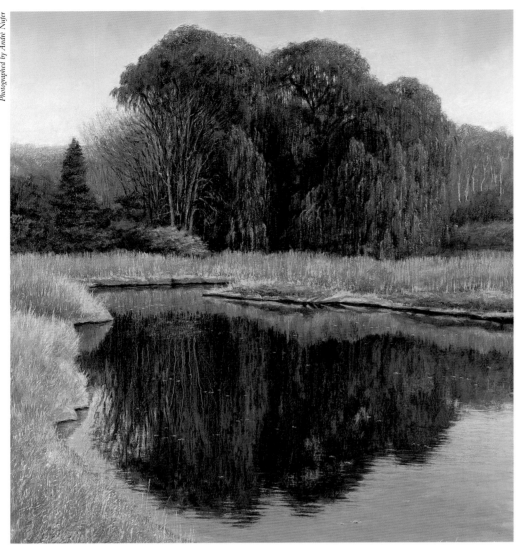

Willow
1992
Oil on paper
32 x 32 inches

Photographed by André Nüfer

The Coves
1976
Oil on board
28 x 32 inches

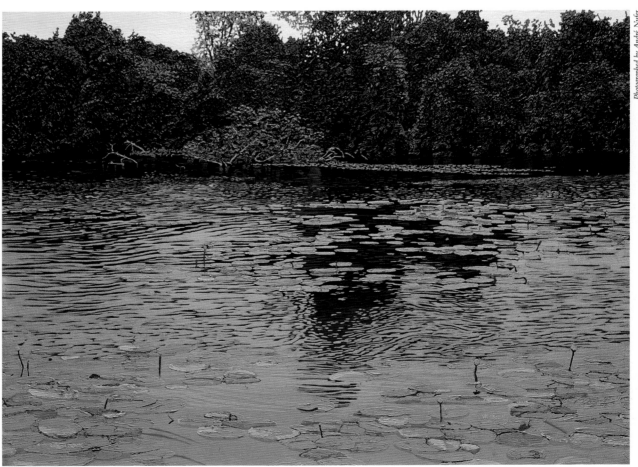

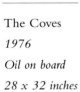

Photographed by André Nufer

Evening Calm
1990
Oil on canvas
24 x 30 inches

Grain Wagon
1980
Mixed media on paper
22 x 30 inches

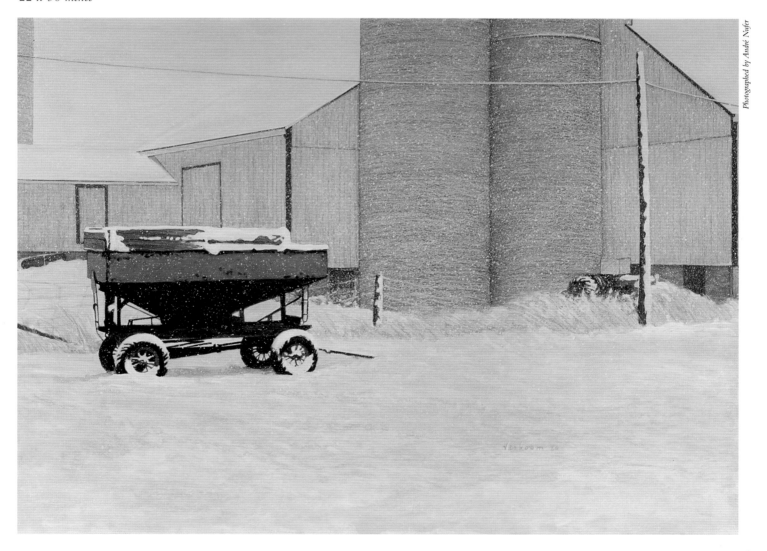

Photographed by André Nufer

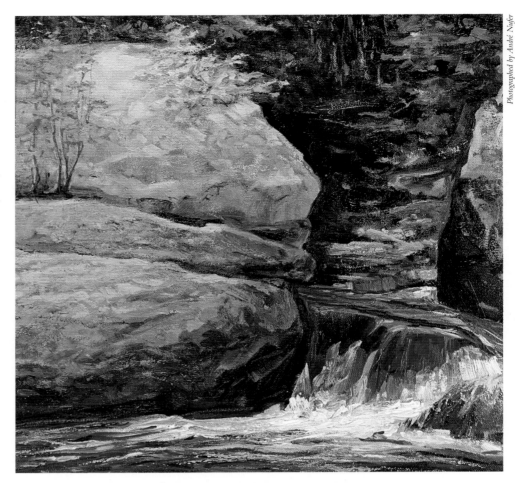

Photographed by André Nüfer

Mountain Rush
2001
Oil
12 x 12 inches

Roots
1980
Oil on board
20 x 30 inches

Photographed by André Nüfer

Photographed by André Nufer

Up and Down the Mountain
2001
Oil
18 x 24 inches

Trail of Friendship
50 x 50 inches
Oil on canvas

Photographed by André Nufer

Photographed by André Nufer

Field Study
2000
Oil
12 x 12 inches

Reflections
1976
Oil on acrylic on board
32 x 32 inches

Photographed by André Nufer

BETSY ELLIOTT ZUKIN

Art and creating have always been my life. Epilepsy entered my life at the age of 26. The onset was traumatic and medically unexplainable, and has been a catalyst toward forming the introspective self-expressions found in my artwork. Epilepsy requires control, both medically and physically. Control—inside and outside—is a theme found in my sculptures.

Prior to having epilepsy, I used more structured mechanical tools such as looms, machinery, and screen-printing to create my work. My sculptures now are constructed with my hands. The structures are handwound and twisted. I physically climb into the pieces as I create them. Traditional weaving and binding techniques are used with thin wires and fibers such as waxed linen to create the structure and pattern of each sculpture. Through repetition of patterns, a series of new patterns are created and control exists within the world of each sculpture.

There is a physical involvement in each piece that is a continuing search to express my ideas and observations of myself in a sculptural form. Each piece is a self-portrait or an expression of emotion. I have chosen to make my epilepsy an asset to my life, through self-expression.

Photographed by Jack Ramsdale

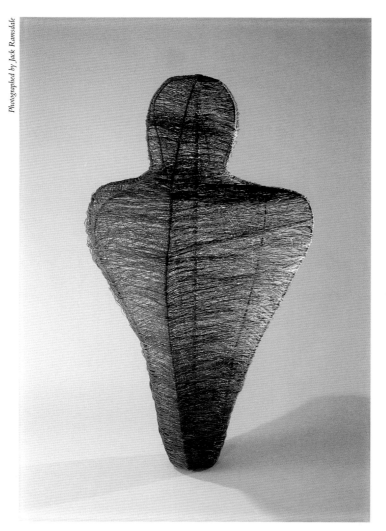

Bound for Life
1991
Stainless steel rod, copper, patina
30 x 30 x 62 inches

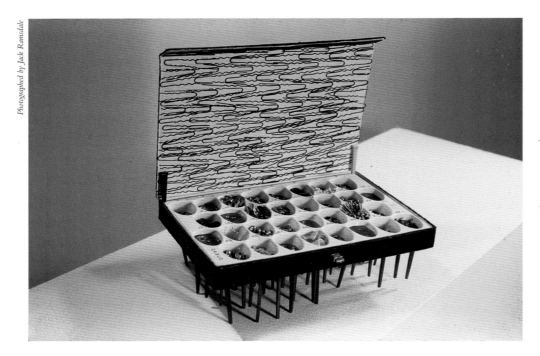

Photographed by Jack Ramsdale

Box of Life
1994
Box, nails, hairpins, toys
18 x 11 x 7 inches

Installation of 4 Pieces
1992
Galvanized steel, copper wire, linen
140 x 67 x 72 inches

Photographed by Jack Ramsdale

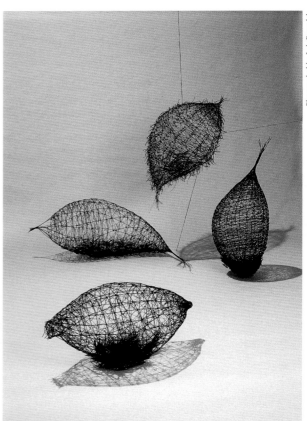

Coiled
1991
Copper and steel, wire, solder
12 x 47 x 18

Photographed by Jack Ramsdale

BIOGRAPHIES

PATRICIA BERNARD

My work is increasingly popular and has been shown locally in Cabrillo College and University of California at Santa Cruz, as well as Harvard University, Stanford University, Carmel Valley, and Big Sur.

At this time in my life, marketing my art is of greater and greater importance to me.

For more information about me or purchasing my art work, please contact me at:
Patricia Bernard
721 Rosedale Ave. #11
Capitola, CA 95010
Phone: 831-475-1746
e-mail: Artist@smileyface.com
Website: www.PatriciaBernard.com

ELENA BLAISDELL

I was born in New York City in 1951, and went to The High School of Art & Design and F.I.T. I was a fashion illustrator and catalog designer on Madison Ave. until 1972 when I got married and moved to St. Paul. In 1975 I went to work for Hubbard Broadcasting as a production artist and promotion assistant. I continued working full time in the arts until 1985 when I went back to college. I was born with epilepsy but it never held me back until 1986 when no medication seemed to work for me. In 1991, after being tested with a grid implant, I had a left temporal lobectomy, but had a stroke 3 hours after the procedure. I guess I am an emerging artist once again.

Awards:

2002—$200 Emerging Artist Grant from VSAarts
Art appearing in two GlaxoSmithKline calendars, including on the cover of the 2003–2004 calendar.

Exhibitions/Performance History:

2000 at The University of Minnesota.—VSAarts Exhibit for Vision Loss
1996, 1997, 1998—American Kennel Club Art Show at the Dog Show, Kansas City
2002–2003—Metropolitan Council Exhibit

Collections:

Multiple exhibits and international publications

I can be contacted at:
Elena Blaisdell
6420 Carleda Way
Invergrove Heights, MN 55076
e-mail: easelwaz@msn.com

VINCENT BUCHINSKY

Rooted in Abstract Expressionism, Vincent's paintings are animated, edgy, restless creations. Whether whimsical or somber in tone, they struggle to escape the constraints of traditional art and the very canvas they are painted on.

Bold primary colors cry out with elation or invoke inner reflection. Even negative space is not silent but alive. Vincent imbues basic, deceivingly simple colors and shapes with powerful emotions.

This body of work reflects Vincent's struggle to find the delicate balance between unbridled spontaneity and a controlled mastery of his medium. He has a tremendous gift for bringing the abstract to life, to make it leap from the canvas, demand our attention, and seize our hearts and minds.

In 1995 Vincent turned to the digital medium. His digital art evolves from his solid, prolific traditional background in Fine Art. His medium may be different, but his powerful images speak the same language of raw emotion. He has redirected his inner visions, initially brought to life through clay, paint, and canvas, and has now taken command of the common "impersonal" materials of the computer age hardware, software and pixels.

Vincent's work emanates from his heart and soul and has transcended the sterility some may associate with computer-generated images. He has given digital art a life of its own, a life of complexity and stunning beauty.

Vincent earned his BFA at Pratt Institute in Brooklyn, New York, and his MA at Montclair University in Montclair, New Jersey. He teaches computer graphics at Harrison High School and Sussex County Community College and is a recipient of the Geraldine R. Dodge Foundation Grant for Computer Animation.

Other publications:

Ortho-McNeil Pharmaceutical and East West Connection—Image used for poster for an Art Contest

Two cover illustrations for *Epilepsy & Behavior,* edited by Dr. Steven C. Schachter, Harvard Medical School, published by Academic Press, Division of Elsevier Science,

April 2001 and December 2001

Image used in "Reflections"—2002 Calendar published by GlaxoSmithKline (Lamictal)

Vincent can be contacted at:
Vincent Buchinsky
18 Clinton Street
Newton, NJ 07860
Phone: 973-579-3072
e-mail: crayonz@tellurian.net
Website: http://www.vincentjohn.com
 http://www.seizureart.com

JIM CHAMBLISS

Jim can be contacted at:
Jim Chambliss
1800 South 2nd Street, #A44
Louisville, KY 40208

PAMELA DAVIS

One day out of the blue at age 6 it occurred to me that I was instilled with a certain ambition that inspired me to march into the front room and announce, "I am going to be an artist when I grow up."

Through the years art has been an important part of my life. Entering art contests, submitting art to school newspapers and creating all-occasion flyers/banners for school was a good platform for me to learn my skills, and in fact generated my first commissioned jobs. One of the first was in junior high school thanks to a guidance counselor named Mrs. Erwin. My art is still in her office.

For the most part painting pictures kept me busy through school and I even had a small bank account. The most requested subjects were usually people, animals, and beach scenes. After high school I never stopped painting or selling or entering juried shows prior to having four girls, now 7, 10, 14, and 17 years of age. When the youngest was 3 years old, it was a good time for me to go to college to further cultivate my talent by earning an Education Arts major. I am interested in teaching college level visual arts and maintaining a career as an artist by painting and showing new works.

I can be contacted at:
Pamela Davis
1731 S. W. Waters Street
Arcadia, FL 34266
Phone: 863-993-3075

ISABELLE DELMOTTE

Isabelle Delmotte, born and raised in France, has been involved with digital technology for the past 14 years. She has been living and working in Australia for the past 13 years and has exhibited works in various countries. Some of Isabelle's work can be viewed on her website at http://www.isabelledelmotte.net.

She can be contacted at:
Isabelle Delmotte
"Vaimedia"
P.O. Box 1574
Byron Bay NSW 2481
Australia
e-mail: isabelle@isabelledelmotte.net

a B.S. in chemistry at the University of Oregon in Eugene. He received his degree in 1988. After that, he worked as a research chemist in Bend, Oregon, and after that as an analytical chemist in Portland, Oregon. When he reached his late thirties, the frequency of seizures increased making it difficult for Craig to work in the laboratory. In 1997 Craig made the decision to go back to school to pursue his dream of becoming an artist. Now, 4 years later with paintbrush in one hand and a BFA in the other he is ready to take on the world.

He can be contacted at:
Graig Getzlaff
4612 S.E. 71st Avenue
Portland, OR 97206
Phone: 503-777-4860
e-mail: : craignlori@pacifier.com

JENNIFER HALL

Jennifer Hall is an artist who has been working with interactive media for over 20 years. She is experienced in the research and production of interactive media projects and is engaged in the refocusing of biological material as an art form.

Ms. Hall received her Bachelor of Fine Arts (B.F.A) at the Kansas City Art Institute in 1980 and her Masters of Science in Visual Studies (M.S.V.S.) from the Massachusetts Institute of Technology (M.I.T.) in 1985. Ms. Hall is the Founding Director of the Do While Studio, a Boston-based, not-for-profit organization dedicated to the fusion of art, technology, and culture. She has taught at the Visible Language Workshop at the Massachusetts Institute of Technology, The School of the Museum of Fine Arts, Boston, Massachusetts, the Institute de Arte de Frederico Brandt, Caracas, Venezuela, and is currently a Professor of Art Education and Coordinator of the MSAE in New Media Program at the Massachusetts College of Art, Boston.

In both 1984 and 1985, Ms. Hall received the IBM Home Computing Award for developing gesture-driven interfaces. In 1995 she received an honorary award from the Boston Epilepsy Association for her work with Art and Epilepsy, and was awarded the first Anne Jackson Award for Teaching from the Massachusetts College of Art. In 2000 she was the first recipient of the Rappaport Prize, awarded thorough the Decordova Museum and Sculpture Park.

She can be contacted at:
Jennifer Hall
Do While Studio
122 South Street
Boston, MA 02111
Phone: 617-338-9129
e-mail: jenhall@massart.edu

ROXANNE HILSMAN

Roxanne Hilsman is a native of Hoosick Falls, New York. She began art lessons at the age of 7 and has drawn and painted her entire life. Her first real exposure to oils was in San Francisco, while in college and working at the San Francisco Museum of Modern Art Rental Gallery.

She moved to Mississippi in 1987, earned a Master's in Art Education at Mississippi College and taught art at St. Andrew's Episcopal School for 10 years, and part-time at Hinds Community College. After quitting full-time teaching in 1997, she returned to her own work.

She can be contacted at:
Roxanne Hilsman
Jackson, MS
e-mail: hilsman@bellsouth.net

TIM HULTS

Tim Hults is a native New Yorker. He has struggled with epilepsy since he was a year old. As a teenager, his uncle bought him his first camera and photography became his passion. After falling in love with the landscape of the southwest, he moved to Arizona in 1989. He is a freelance photographer and has had his photos displayed at the Scottsdale Center for the Arts. He also has his work currently showing at The 70 NW Gallery in Pennsylvania.

Tim is also an avid animal lover and spends much of his free time doing volunteer work. He volunteers for Wild at Heart, an owl rescue group in Cave Creek, Arizona. He also volunteers for Horses Help in Phoenix. They give therapeutic horseback riding lessons to people with epilepsy and other disabilities. In the summer he is a counselor at Camp Candlelight, a camp for children with epilepsy in the cool pines of Heber, Arizona. He enjoys taking road trips to photograph the southwest, especially the Four Corners area.

He can be contacted at:
Tim Hults
Phoenix, AZ
e-mail: giveahoot2@cox.net

LEONARD LEHRER

Leonard Lehrer is a painter and printmaker. His work has been seen throughout the world in international exhibitions. He has had 40 one-person exhibitions in the United States, Germany, and Spain. Notable museums have acquired examples of Lehrer's work for their permanent collections including the Museum of Modern Art and the Metropolitan Museum of Art, New York; the National Gallery of Art and the Library of Congress, Washington, D.C.; the Philadelphia Museum of Art; the Cleveland Museum of Art; the Albright-Knox Art Gallery; the Sprengel Museum of Art, Hannover, Germany. He has

written various articles and has been a speaker at many conferences and symposia including the First International Conference of Fulbright Scholars in Delphi, Greece in 2000. He has been curator for several international print exhibitions and his work is cited in a variety of art catalogues, journals, anthologies, and books. Former Director of the School of Art, Arizona State University and Chair, Department of Art and Art Professions, New York University he now serves as Dean, School of Fine and Performing Arts, Columbia College Chicago. Lehrer also serves as a Trustee of the International Print Center New York (IPCNY), Board of Directors of Apex Art Curatorial Program, NY, Advisory Board member of SEMAT (Site for Electronic Media, Art and Technology), a division of Pyramid Atlantic near Washington, D.C., and is Chair of the Arts Advisory Committee to The College Board, NY. He has been the recipient of numerous awards including the Grand Prize of the Heitland Foundation, Celle, Germany, a USIA Academic Specialist Grant to the University of the Andes, Bogota, Colombia, a 2000–2001 Fulbright Scholar Program Grant in Printmaking to Athens, Greece, and a 2003–2005 Fulbright Senior Scholar Program grant for a collaborative project between Columbia College Chicago and the Athens School of Fine Arts, Athens, Greece.

He can be contacted at:
Leonard Lehrer
3240 N. Lake Shore Drive, Apt. 16C
Chicago, IL 60657
Phone: 773-549-1939
e-mail: Lmakpl@aol.com

GERIE LEIGH

Gerie grew up in suburban New Jersey and learned to take her shift in the family grocery store at an early age. She graduated from Rutgers University with a BA in Education and Fine Art and started teaching art in the New York City public schools in 1967. She earned a Master's degree in Art Education from CCNY. In 1972 she sailed to Florida with husband and 12-month-old daughter, settled in Jacksonville, and resumed her teaching career.

She taught art to gifted and advanced high school students and received awards from state and national organizations for excellence. She found time for numerous community and environmental projects, from garbage to manatees, and involved her students in these activities. She initiated the first successful effort to implement tree preservation and landscape ordinances in Jacksonville.

Gerie taught for a total of 31 years in public schools until she was forced to retire after a minor auto accident left her with epilepsy. She has been married for 30 years and has two fabulous grown children, a wonderful son-in-law, and three really, really cute granddaughters.

She can be contacted at:

Geraldine Hidi Leigh
6026 Heckscher Drive
Jacksonville, FL 32226
Phone: 904-751-2997
e-mail: ghidi4@aol.com

TONI L. LUCAS

She can be contacted at:

Toni L. Lucas
e-mail: tllucas@aristotle.net

DEBORAH MAIALE

She can be contacted at:

Deborah Maiale
1496 Hawthorne Road
Grosse Pointe, MI 48236
e-mail: maialemetal@msn.com

MAUREEN METZLER

She can be contacted at:

Maureen Metzler
40 Waterhouse Street
Somerville, MA 02144

SCOTT OVERSTREET

American primitive artist, Scott Lawrence Overstreet, was born December 9, 1963 in San Francisco California. He was "transplanted" to Jacksonville, Florida at age 3 to be raised by his fraternal grandparents.

His interest and aptitude for both art and music at an early age can be attributed to Scott's exposure to the arts in the Overstreet home, as his grandmother was both an accomplished pianist, violinist, as well as a portrait, floral, and landscape, oil painter. Being supplied with pencil, crayon, loving encouragement, and tutelage, "little Scott" would try to imitate his Grand-Patron by following her about in her office-room/art-studio " makein drawins."

As his interest in drawing and art continued, his interest in music began also. He was armed with his grandmother's early piano tutelage, basic musical foundation, and went on to attend Kirby Smith Junior High School, in Jacksonville, where his more formal foundation in music began as a trumpeter. He graduated Trenton High School, in Trenton Florida, and

by-passed a full scholarship to U.S.F., in Tampa, in both art and music, to enlist in the United States Marine Corps at the age of 17.

Mr. Overstreet has remained a lifelong Floridian. He did not follow either art or music to support himself, but instead was a construction trades craftsman, working on the South Florida coasts as both a skilled interior trim carpenter, as well as a highly skilled custom interior painter. At the age of 30, he sustained a permanent disabling job-related injury, and later that year also developed an epileptic seizure disorder. Forced from his professions, he turned his hand to the art of oil painting to support himself.

Not having attended a formal college or art school, this primitive artist combined his knowledge of the painting trade with his lifetime of casual, occasional pencil sketching and drawing, along with his carpentry skills and began self-studying/self-teaching the techniques and methods of building/stretching canvases, as well as the various applied methods of oil painting by hand brush.

A resident of the town of Naples, Florida during that period, Mr. Overstreet was given a warm reception to his innate talents and early works by the townspeople and business owners. Several art galleries and restaurant owners featured his early works. The painting entitled "Licking Branch" was bought by a local Naples businessman who donated it to the Naples Wildlife Conservancy Museum, where it currently is on permanent display.

Presently, Mr. Overstreet resides in Sarasota, Florida as a struggling artist on permanent disability. He has displayed paintings in several local art galleries and has been commissioned for several dozen paintings for private collections around the United States.

Other post-epileptic artistic talents include musical composition, and poetic muse.

You can contact him at:
Scott Overstreet
2846 Indian Wood Drive
Sarasota, FL 34232
Phone: 941-343-9873
e-mail: scottworks_inc@yahoo.com
Website: http://artbyscott.tripod.com/artbyscott

DOTTY PEDI

She can be contacted at:
Dotty Pedi
4 State Street
Hudson, NH 03051
Phone: 603-883-5511
e-mail: RPDP64@aol.com

ANSEL PITCAIRN

Ansel Pitcairn, fine artist and illustrator, grew up in Brooklyn, NY. Born in London, England, Ansel is the son of Trinidadians who emigrated to the United States in the early seventies.

After earning his Bachelor and Masters degrees in illustration from New York's School of Visual Arts, he has successfully pursued a career in illustration while showing his fine artwork regularly in one-man and group exhibits. His most recent exhibit was at The American Museum of Natural History in New York City.

Ansel presently teaches an anatomy/figure drawing class at The School of Visual Arts, and is an assistant professor at Long Island University, teaching Computer Graphics.

He can be contacted at:
Ansel Pitcairn
330 Lenox Road, Apt. 4E
Brooklyn, NY 11226
718-940-2973
e-mail: anselp@earthlink.net

SIMON POWELL

He can be contacted at:
Simon Powell
Merchants Court
22, Fore St. Fowey
Corwall, PL23 1AQ
United Kingdom
Phone: 01726-833097
e-mail: simonfowey@aol.com

VOLKER RODERMUND

He can be contacted at:
Volker Rodermund
C/o Margarete Pfafflin
Epilepsy Centre Bethel
Maraweg 1
33617 Bielefeld
Germany

CINDY ROSS

She can be contacted at:
Cindy Ross
669 N. Carpenter Street
Chicago, IL 60622
Phone: 312-738-2060
e-mail: cindy@cniktiles.com
Web site: www.cniktiles.com

JUDE ROUSLIN

Jude's entire website, *Inside Out Graphics,* is showcased in Seoul, Korea, Seizure Free Art Gallery. Jude was approached by the Korean group when they viewed her work on the Internet. She was invited to display her United States-based website for the website *Seizure Free* to the Korean community to help advocate and display her visual achievements. *Seizure Free* website http://www.seizure.co.kr

Jude has also been approached by *Epilepsy.com* for inclusion of her seizure-related works on their site. Her works may be viewed online at "The Gallery" epilepsy.com.

Other accomplishments and publications:

Contributing cover artist for the award-winning neurological journal, *Epilepsy & Behavior,* published by Academic Press:

June 2001—*Abstract*

October 2001—*Stamped in the Minds of Many*

June 2002—*Statue of Liberty*

City on Tile appeared in the 2002 calendar *Reflections: An Exhibition by Artists Living with Epilepsy,* sponsored by GlaxoSmithKline.

The artist also has had works displayed at various neurological conferences throughout SW Florida:

2001: American Epilepsy Society—*Neuroendocrinological Aspects of Epilepsy;* Cover Design

2000: American Epilepsy Society—Cover Design: *Seizure on the Street*

Conference brochure:

Abstract Communications

Ignorance Is Not Bliss

Shadows

Abstract

Epilepsy Services of Southwest Florida—Epicon 96' logo design and contributing artist for neurological symposium. Sarasota Memorial Hospital

Epicon 97' logo design and contributing artist for neurological symposium. Fort Myers,
 Florida.
Tampa General Hospital—Neurological conference and symposium. Works displayed
1994 March of Dimes Celebrity Eggspose—Contributing artist for Silent Auction

The artist also has canvassed works on permanent display at the Epilepsy Services of
 Southwest Florida, as well as in the private sector. Jude's works are also currently
 exhibited at The Rhode Island Superior Court House and Broadway Knights Art
 Gallery, in Providence, RI. She has also participated in various mainstream art shows in
 S.W. Florida.
1994 art director for children's art program at Rosemary Court, via a H.U.D. grant.
 Children's work was on display at Ringling Art Museum Summer Program.
1990 A National Exhibition of Work by Artists with Epilepsy—*The Strength of the Mind,* The
 Epilepsy Society of New York City, Inc.

She can be contacted at:
Jude Rouslin
4649 Hollingsworth Ave.
Sarasota, FL 34233
Website: www.insideoutgraphics.net

ALEXANDRA ROZENMAN

Alexandra Rozenman was born in the Soviet Union, the country of "unhappy strugglers."
The absurdity of Soviet life and the beauty of Russian culture set up her love of storytelling,
painting, and image-making. In need to escape toughness and political danger around her, she
painted paintings with dreamlike scenes, often in childlike style.

She escaped Russia as a political refugee in 1989. Her Bachelor degree is from Empire
State College, SUNY and her M.F.A. comes from The School of the Museum of Fine Arts
and TUFTS University in Boston, MA.

She is currently represented by AZ Gallery in St. Paul, MN and CLARK Gallery in
Lincoln, MA and was an invited artist at the Creole Gallery in Lansing, MI. She was a
Ragdale Foundation fellow in 2001. The same year, she was accepted to The Drawing
Center in New York. She received a Hambidge Center residency fellowship for August in
2003. She currently resides in St. Paul, MN and is a faculty member at Minneapolis College
of Art and Design.

She can be contacted at:
Alexandra Rozenman
e-mail: Alexandra@rozenart.com

JON SCHROCK

He can be contacted at:
Jon Schrock
2253 3rd Street
Laverne, CA 91750
Phone: 909-392-7607

STEVEN SOMMOVIGO

He can be contacted at:
Steven Sommovigo
6501 Sunny Hill Court
McLean, VA 22101
Phone: 703-356-3782

JACQUI STREETON

Jacqui Streeton started drawing at the age of 5. Even though she was already having seizures, her epilepsy was not diagnosed; in fact, most of the adults in her life believed that she was possessed by demons. Because of this belief, each time she had a seizure, she was beaten and placed in a room by herself, probably to isolate her from the other students in the private school she attended at the time. In this room, she had access to a pencil and paper, and it was during these times that Jacqui turned to drawing the religious objects and paintings that surrounded her.

Just before she graduated from college in 1987, she was hospitalized for status epilepticus. The resulting loss of memory left Jacqui unable to remember the previous 30 years of her life. She was unable to speak or walk. Her ability to draw and paint was also lost. However, with the help of neuroscientists, who taught her how to compensate for her memory loss, and many years in rehabilitation, she finally regained her abilities and started once again to draw and paint.

She set about learning everything she could about epilepsy and discovered that there was a huge amount of ignorance with regard to this disorder. She decided to use her artwork to educate the public not only about her own experiences, but epilepsy in general. Her work is varied and includes portraits of famous people, some of whom had epilepsy, as well as interpretations of her feelings before or after her seizures. She has also been instrumental in involving young artists with epilepsy, for example by encouraging them to exhibit their works.

Known also as "The Thornbird," Ms. Streeton's artwork is displayed internationally and has been published in *JAMA, Medical Journal of Australia,* on covers of books about epilepsy, and also in calendars.

Despite her ongoing problems with short- and long-term memory loss and seizures, she continues her crusade to educate "through the eyes as opposed to the ears."

She can be contacted at:
Jacqui Streeton
2324 Georgetown Rd.
Cleveland, TN 37311

HOWARD SWIEL

Studied photography at Port Elizabeth Technikon, Port Elizabeth, and Rhodes University, South Africa.
Worked as a photojournalist in Cape Town, South Africa.
Photos published in different magazines and newspapers in Cape Town, South Africa; New York, United States; Lausanne, Switzerland, and Cluj, Romania.

Exhibitions:

Rhodes University Group Exhibition
1998–Photo Vision, Lausanne
1999–Clinique Valmont
2000–I.D.H.E.A.P., Lausanne
2001–Musee National D'Art, Cluj, Romania

You can contact him at:
Howard Swiel
Eterpeys 6
1010 Lausanne
CH, Switzerland
Phone: 412-1653-6425
e-mail: margitta.seeck@hcuge.ch

JAMES TALIN

James Talin and his sister Pamela Talin-Bryant have run the Talin Bookbindery on Cape Cod for 25 years. They were among the first American binders to practice and revitalize the ancient art of Turkish marbling, which consists of floating and manipulating watercolors on a surface of Irish moss sea weed. Their work was featured in the 1982 book, *American Decorative Papermakers* (Busyhaus). More recently they have been the subject of articles in the *Boston Globe* and the *Cape Cod Times,* and they were featured in a segment of the Boston area television show *Chronicle*. As binders, they restore and rebind antique and new books. They also make boxes for books and other collectibles, and they produce a variety of marbled papers.

You can contact him at:
James Talin
Talin Book Bindery
947 Route 6A
Yarmouth, MA 02675
Phone: 508-362-8144
e-mail: talinbookbindery@yahoo.com
Website: www.talinbookbindery.com

DAVID THINGER

Artist David Thinger has won international and national art shows. He was introduced to state senators for a show he won in Michigan. He periodically shows in art galleries.

Galleries:

2003—Mary Freebed Hospital Show, Grand Rapids, MI
2003—Franciscan Life Process Center, Grand Rapids, MI
2002—Gallery 800, Grand Rapids, MI
2002—Franciscan Life Process Center Gallery, Lowell, MI
2002—Lowell Area Arts Council, Lowell, MI
2000—Terryberry Gallery, Grand Rapids, MI (private showing)
2000—Michigan Arts Gallery, Suttons Bay, MI
2000—Reeds Lake Art Fair, Grand Rapids, MI

Freelance Artwork:

Portraits of people and animals, bookcovers, book art, medical art, landscapes, still life, etc.

Art Mediums:

Oil paint, watercolor, pastel, charcoal, colored pencil, Photoshop, etc.

Art Styles:

Realistic, semi-realistic, caricature, cartoon

Awards:

2002—Art chosen for 2003 Perspective Calendar Contest—$500
2000—Art chose for 2001 Perspective Calendar Contest—$500
1999—First Place, 12th Annual Foot Health Poster Contest—$500
1991—First Place Trophy, Creative Category for APGU International Contest, San Diego, CA

Membership:

1999—Grand Valley Artists
1999—Great Lakes Pastel Society

Education:

1983—Cal State University Long Beach, Long Beach, CA, Bachelor of Arts Graphic Design

He can be contacted at:
David Thinger
210 Garfield NW
Grand Rapids, MI 49504
Phone: 616-454-4967
e-mail: dthinger@portraitsbydave.com
Website: www.portraitsbydave.com

KLAAS VERBOOM

Klaas Verboom was born in London, Ontario in 1948 and is a graduate of the Ontario College of Art, Toronto, Canada. His paintings, mostly oils, are reflections of what appeals to him, and range from portraits to landscapes to famous buildings, but they have one thing in common, all are beautiful.

Over the past 30 years, he has been the featured artist in exhibitions at art galleries across Canada and the United States and has also participated in numerous art shows. His commissioned portraits are displayed prominently throughout Ontario. He has also been commissioned by a large number of institutions in the commercial, medical, and art worlds and his works grace lobbies and boardrooms across Canada and the United States. His works are also held in private collections nationwide.

Most recently, he was a finalist (out of 10,000 entries) in an annual art competition held in Cincinnati, Ohio, and was also chosen to participate in the "Oil Painters of America" show in Cohasset, Massachusetts. In 2001, he placed in the top 200 of the worldwide art competition "Arts in the Park," in Wyoming.

Klaas Verboom continues to reside and create in Ontario, Canada.

He can be contacted at:
Klaas Verboom
P.O. Box 829
Parkhill, Ontario
Canada N0M 3K0
Phone: 519-294-6139
e-mail: klaasverboom@home.com
Website: http://ca.photos.yahoo.comm//klaas_verboom

BETSY ELLIOT ZUKIN

Betsy was born in Erie, PA on December 20, 1959. In 1987 She received a Bachelor of Fine Arts degree from the Philadelphia College of Art in 1987 and a Masters of Fine Art from Temple University, Tyler School of Art in 1992.

Selected Collections:

Graduate Hospital

Philadelphia College of Art

Epilepsy Foundation of Philadelphia

Dr. & Mrs. B. Smukler

Pincus Brothers Maxwell Design

Selected Awards

1993—Achievement Award from Joan Rapp, The Central Pennsylvania Crafts National 27

1990–1992—Russell Conwell Fellowship, Temple University

1987—Fibers Faculty Award, Philadelphia College of Art for outstanding achievement
 in crafts

1986—Marcus Renzetti Award for outstanding achievement

She can be contacted at:

Betsy Elliott Zukin

262 Colwyn Terrace

West Chester, PA 19380

Phone: 610-429-2634

e-mail: Thezukins@bee.net

ISBN 0-12-621358-5

90090

9 780126 213584